DAPHNE01

sketches by daphne yap

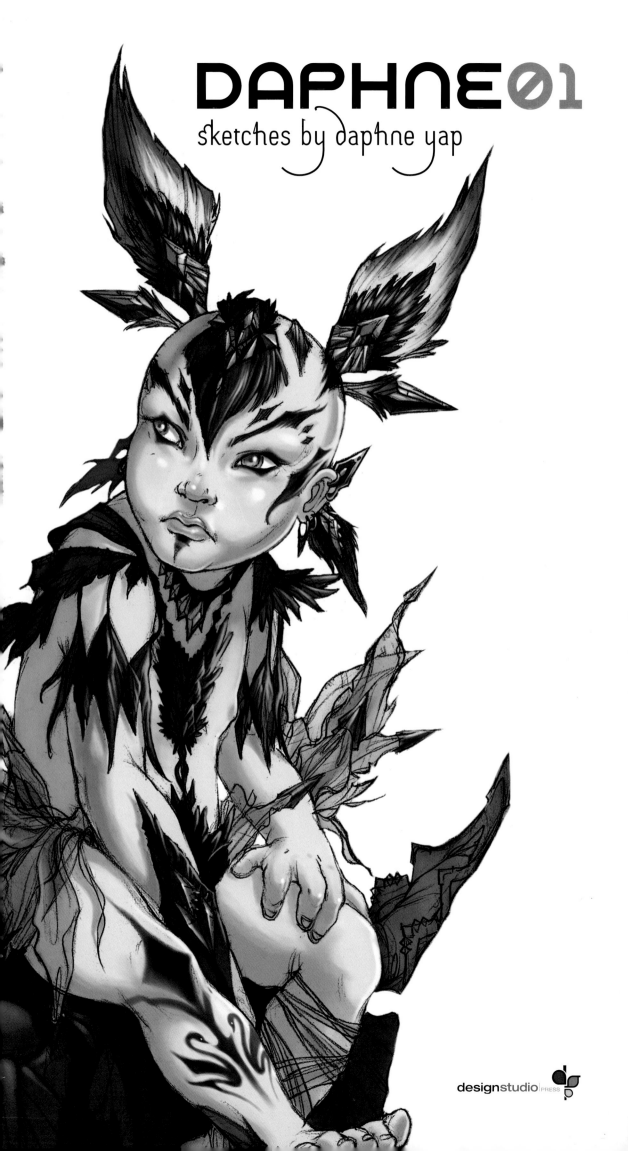

designstudio PRESS

_special thanks:

First, I would like to give many thanks to Scott and Neville for their interest in my work, and for believing in me. Thanks to Gary Geraths for his patience and guidance in my first life-drawing class; to Mrs. Forrester for inspiring me and pushing me to do something I didn't know I could do and for making me believe in myself. Thanks to Mr. Heinrichs for supplying me with new dreams and a future and whatever supplies he had, allowing me to create more art—it made high school more bearable. Thanks to Mr. H. Mott for showing me alternatives in the working field; to my family for all the support and good things that come with it; and all my buddies wherever they may be, for keeping me sane at all hours and inspiring me everyday. Hearts, stars, clovers, and horseshoe-shaped meanings for everyone!!! Thank you all so much.

Layout Production: Marsha Stevenson
Text Editor: Kevin Brown
Graphic Design: Fancy Graphics
Web Site: www.fancygraphics.com

Published by
Design Studio Press
8577 Higuera Street
Culver City, CA 90232
Web site: www.designstudiopress.com
E-mail: info@designstudiopress.com

Printed in China
First edition, May 2006

Hardcover ISBN 1-9334-9208-2
Paperback ISBN 1-9334-9209-0
Library of Congress Control Number:
2005935958

contents

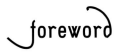

foreword

It is with great pride and enthusiasm that we at Design Studio Press are publishing the first book—of what we hope will be many—by this talented artist. Daphne is a former student of Neville Page and myself, and although I would like to think we had something to do with the refinement of her drawing skills, I'm not sure we can make such a claim.

Daphne has always possessed a level of craft in her work that is very difficult to teach. As an educator, I feel that the best one can hope to do with someone of Daphne's skill level is to provide a creative working environment and engage her in discussions about her designs.

As a publisher, I'm in a particularly unique position to go one step further in helping advance her artistic design career: offering you this first collection of original pencil sketches.

It is rare to find such creative vision and range of design ability within one person. From crazy cats, to unique fashion designs and the Royal Deck collection, we hope you enjoy her work as much as we do, and that you too will encourage her to continue creating her very original works.

Los Angeles, December 2005

Scott Robertson
Founder, Design Studio Press

introduction

I came to art school in LA, thinking I was just going to illustrate... which is funny, because when I was younger, I thought that illustration was defined only as drawing for young kids. When it came time to choose a major, I was torn between several choices: illustration, fashion design, or toy design. Eventually, I chose toy design, because at some level, I felt it incorporated many worlds. However, I didn't realize I had another interest—concept design—until I started doing my own personal art work outside of school. I'm glad I did these pieces, even though I thought they would be just for fun.

-Daphne Yap

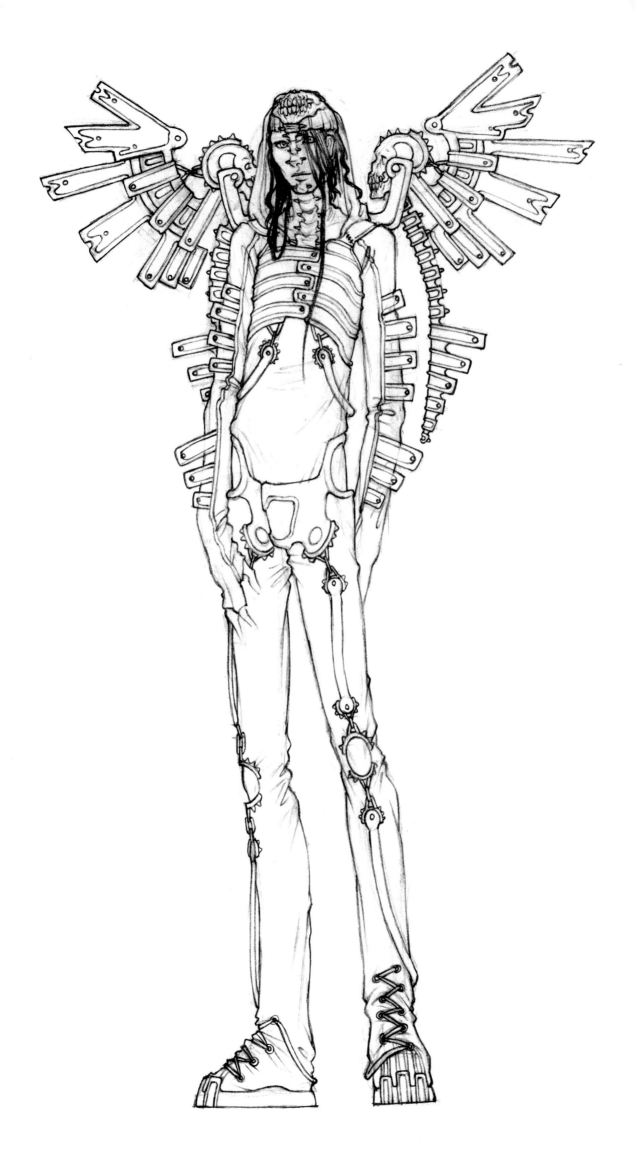

1 FASHION

Here are some designs I decided to work on for fun. They are for fun-wear or anytime-wear, it doesn't really matter. Some are inspired from a trip I had with a friend, some from music, or whatever inspired me at the moment.

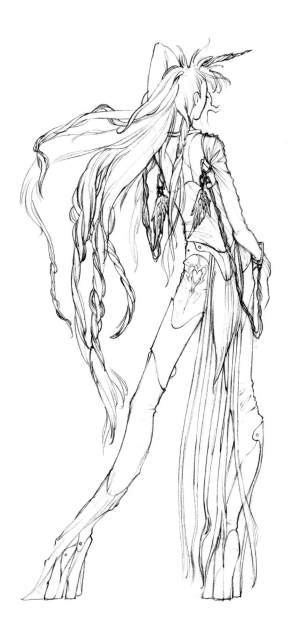

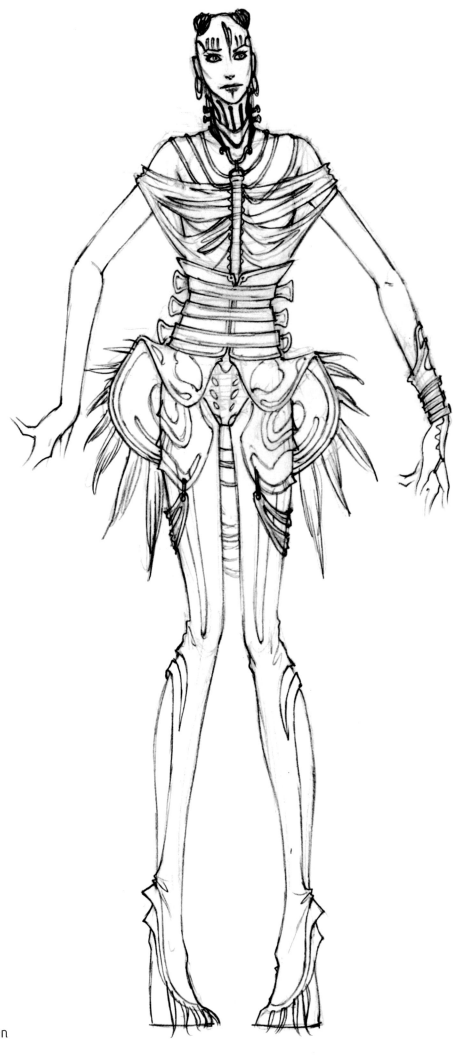

women

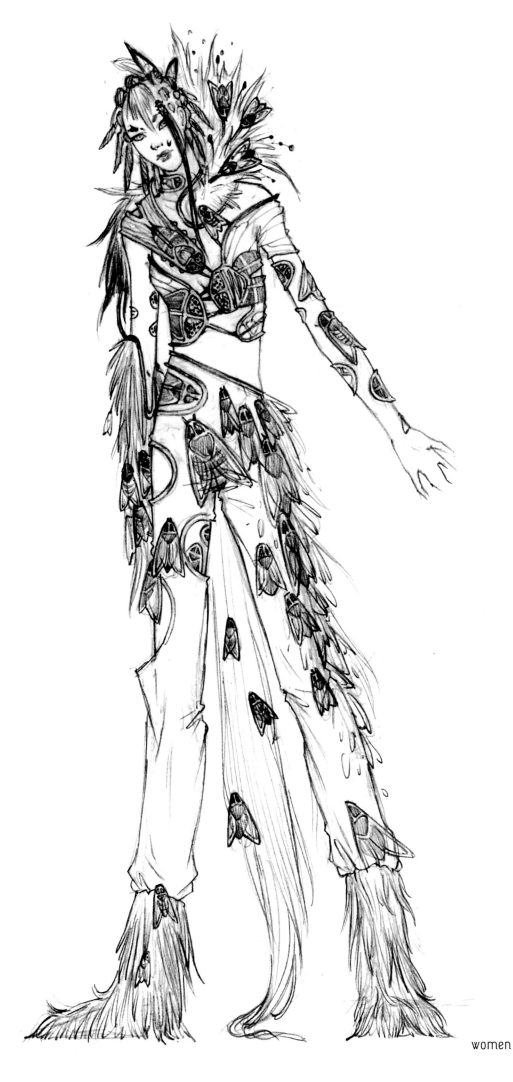

women

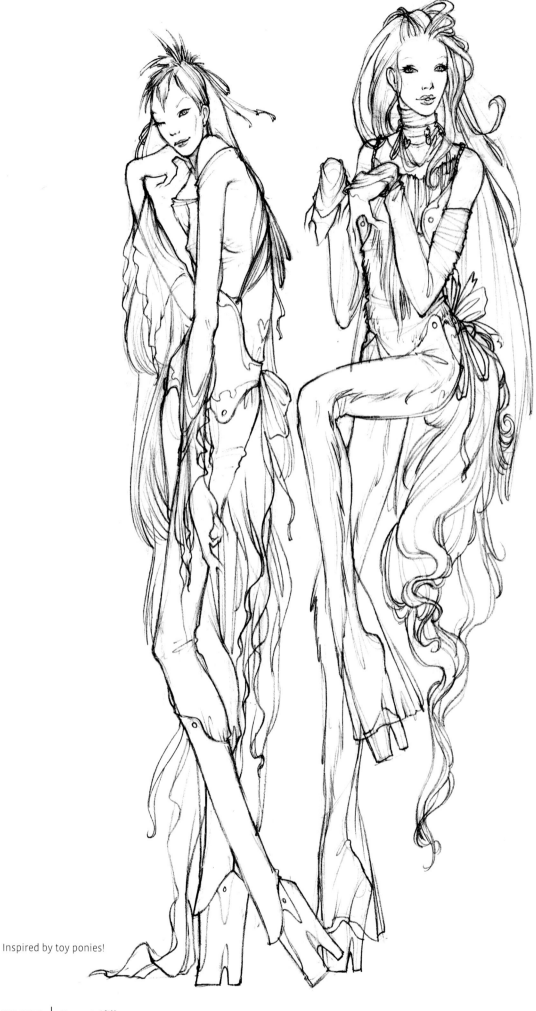

Inspired by toy ponies!

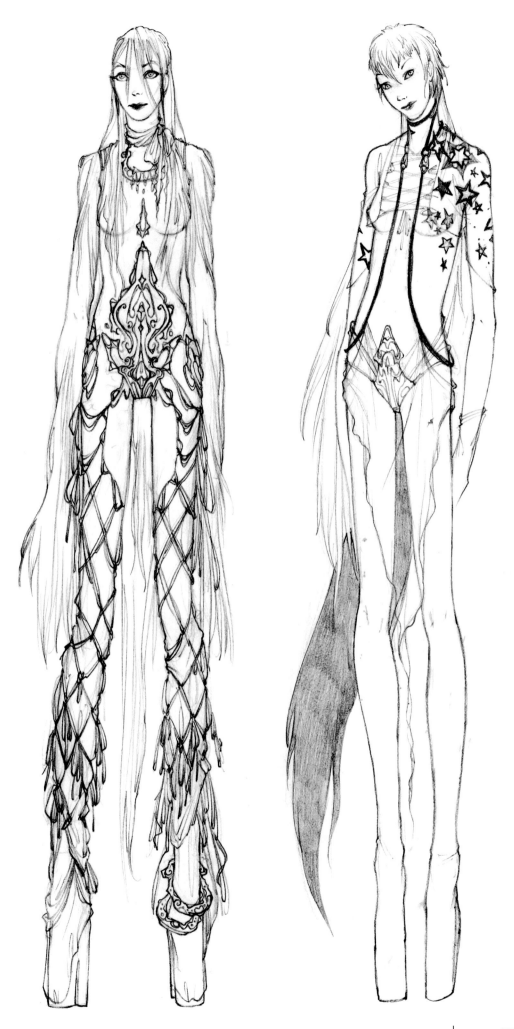

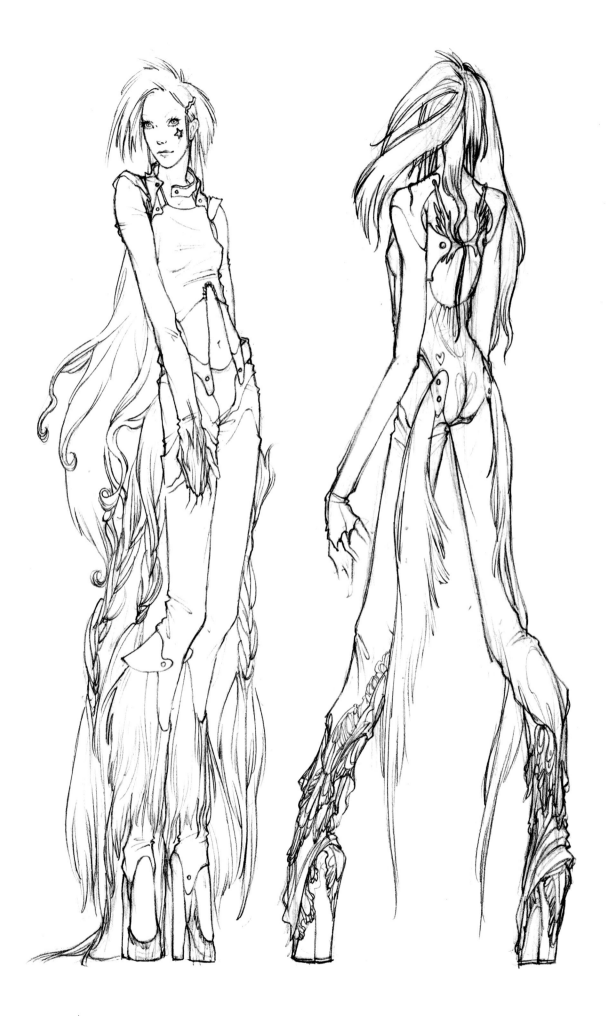

women | Equestrifilles

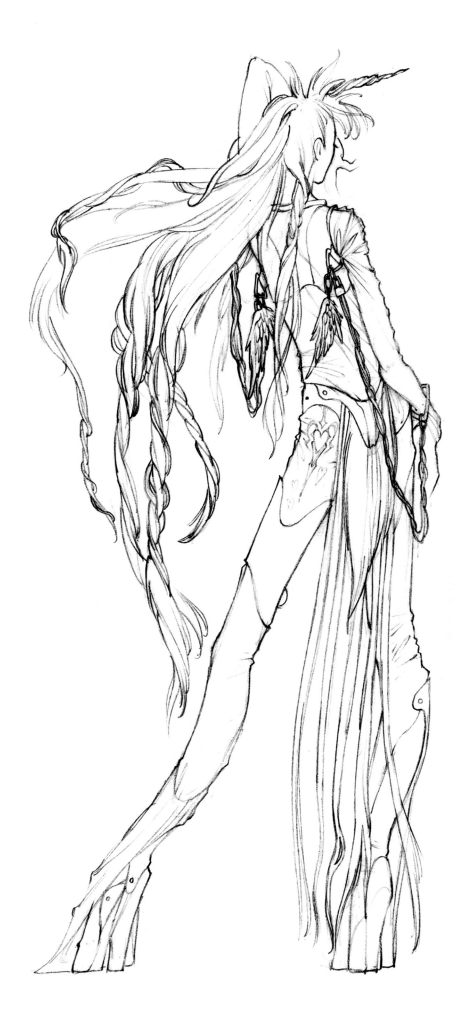

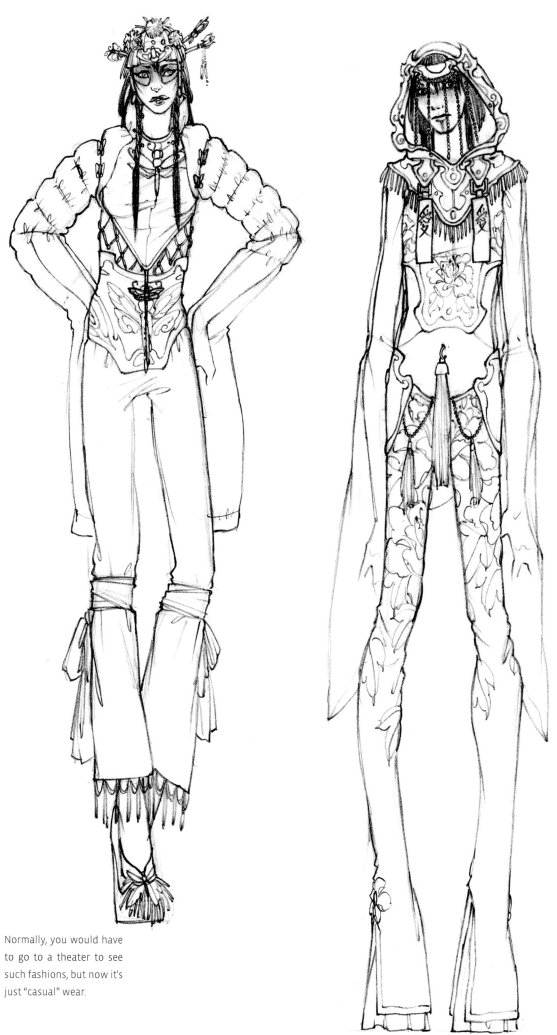

Normally, you would have
to go to a theater to see
such fashions, but now it's
just "casual" wear.

women | from Peking: Opera Wear

14

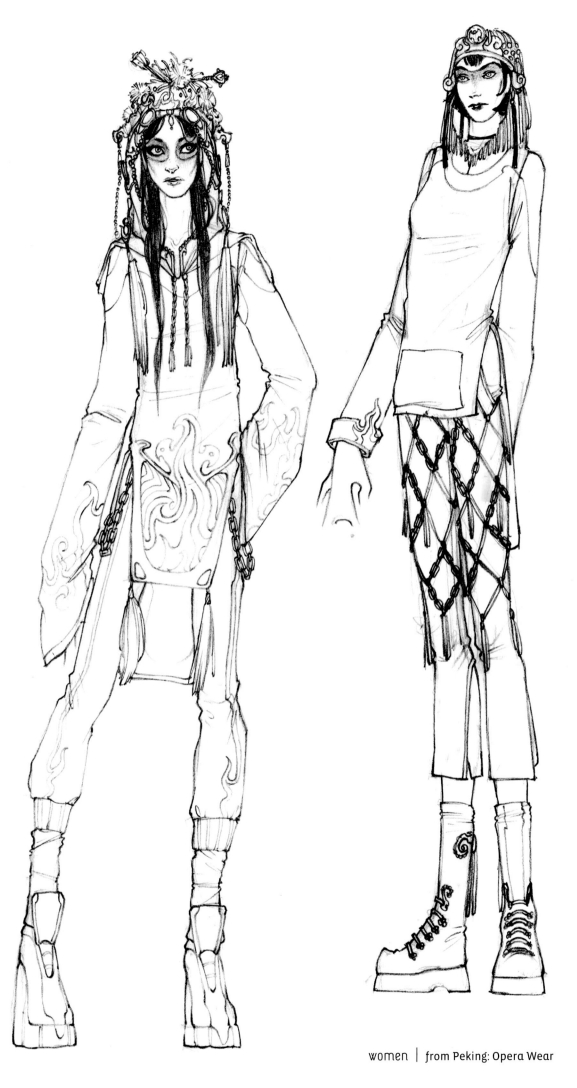

women | from Peking: Opera Wear

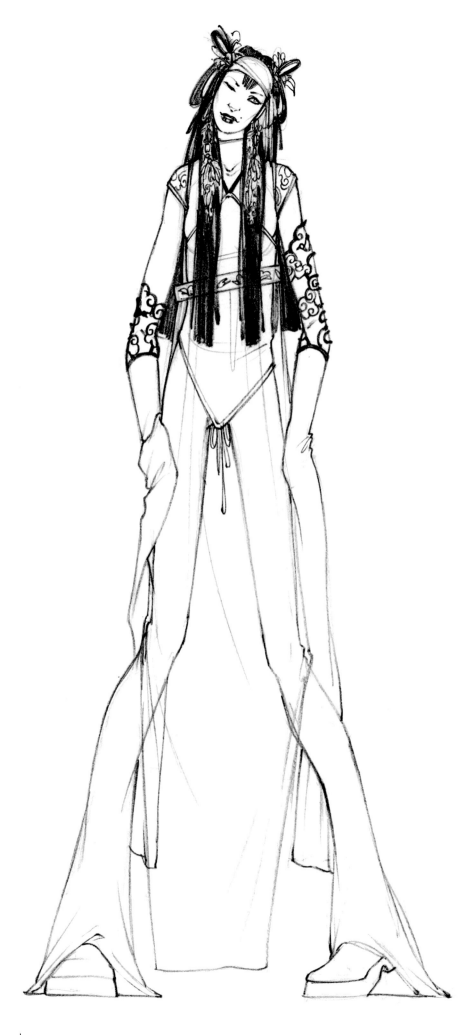

women │ from Peking: Opera Wear

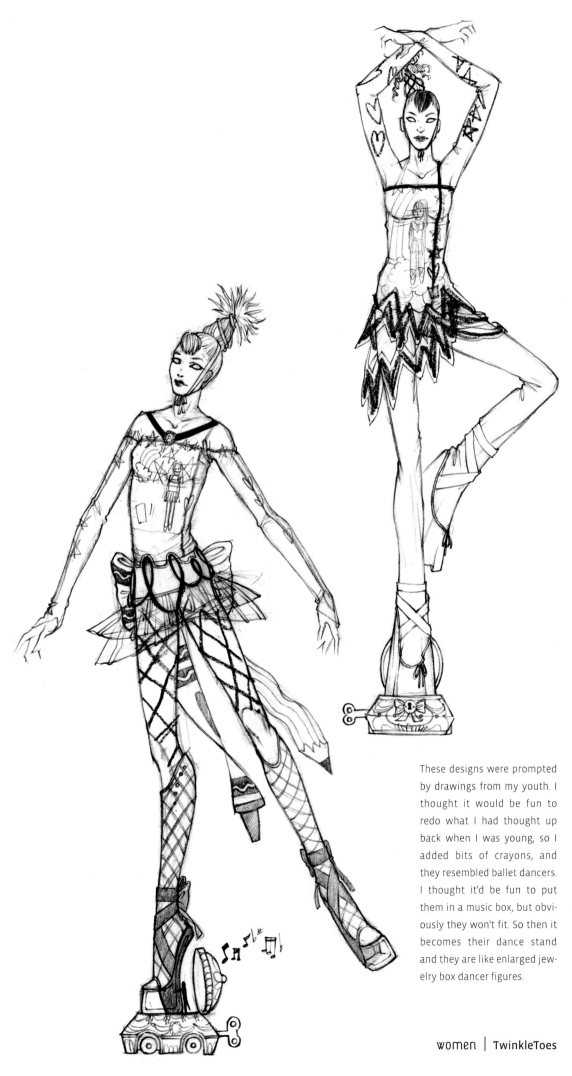

These designs were prompted by drawings from my youth. I thought it would be fun to redo what I had thought up back when I was young, so I added bits of crayons, and they resembled ballet dancers. I thought it'd be fun to put them in a music box, but obviously they won't fit. So then it becomes their dance stand and they are like enlarged jewelry box dancer figures.

women | TwinkleToes

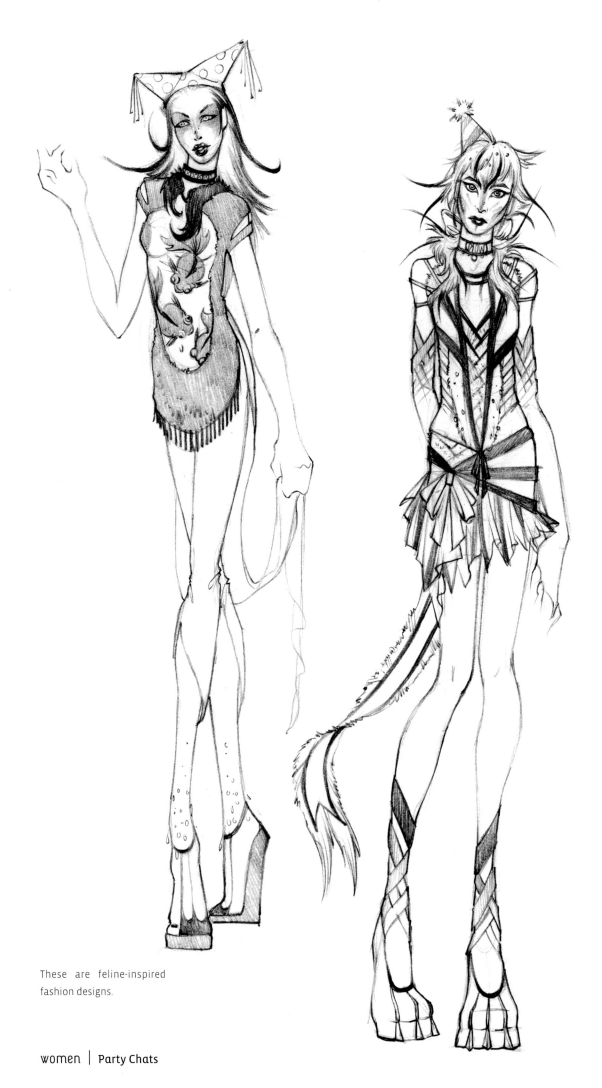

These are feline-inspired
fashion designs.

women | Party Chats

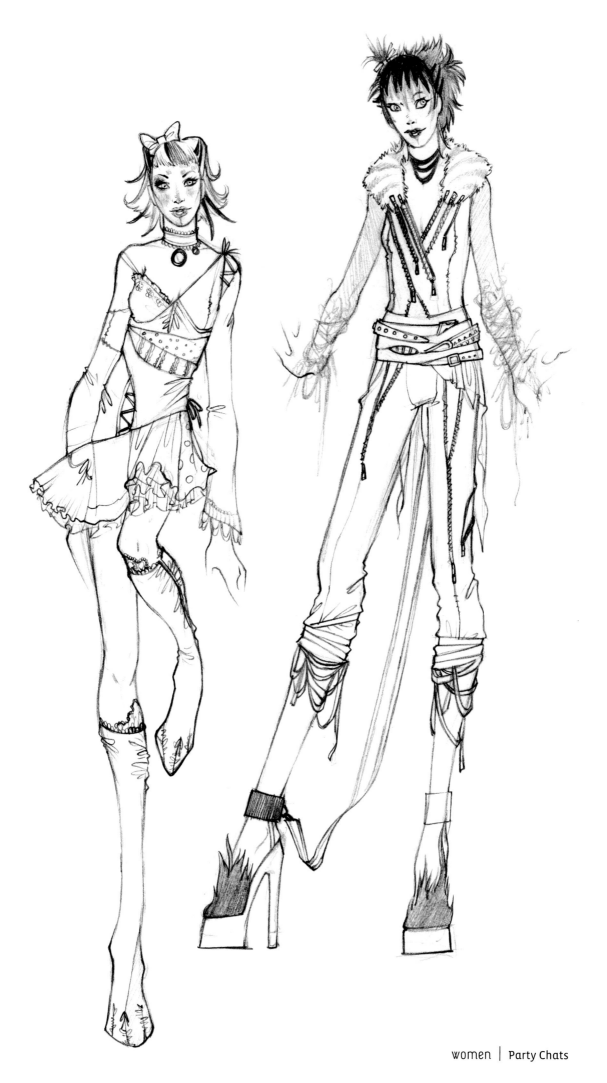

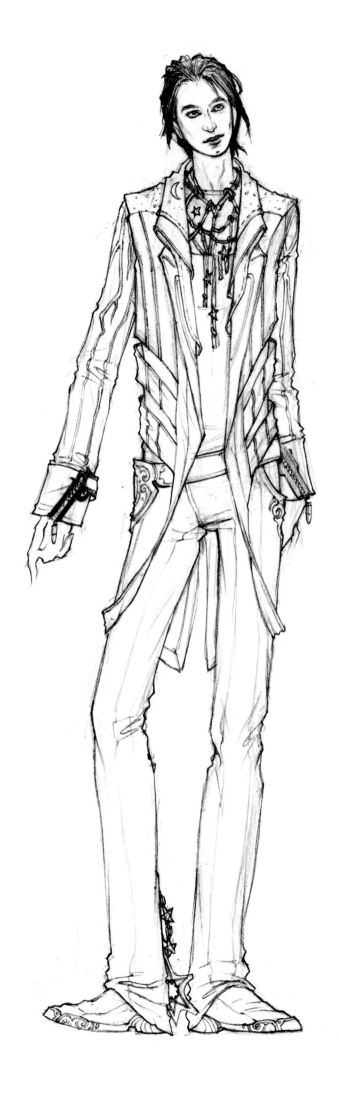

men

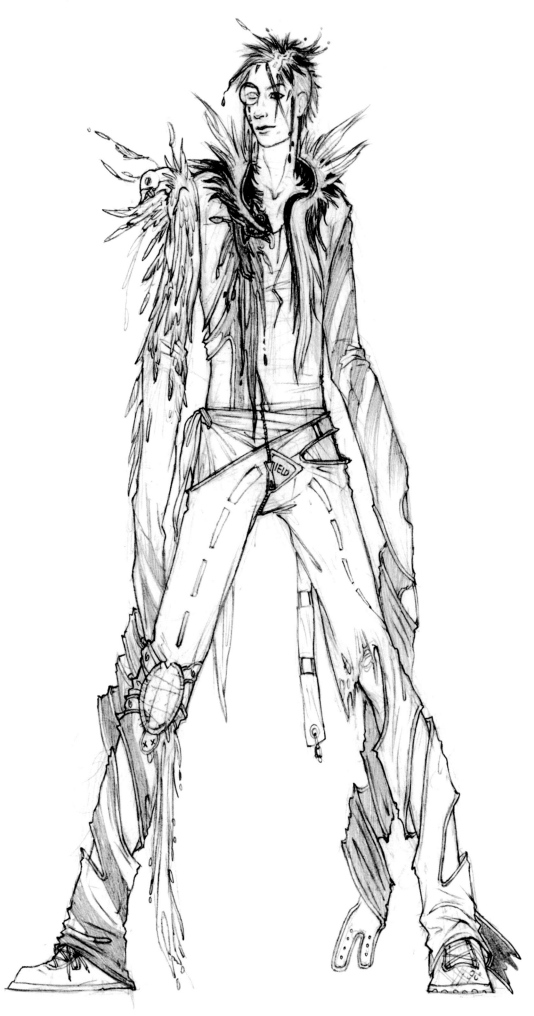

men

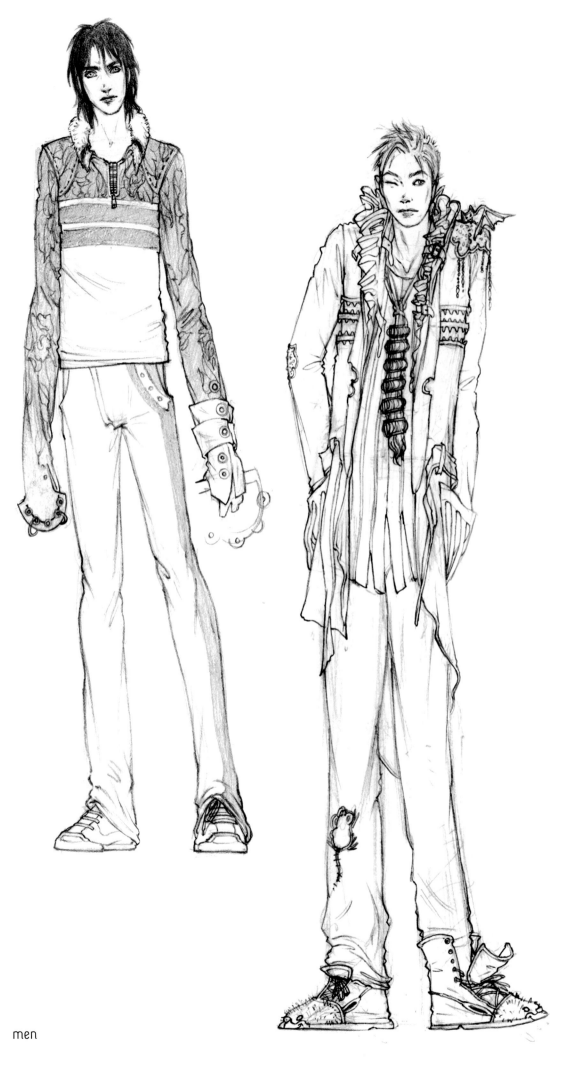

men

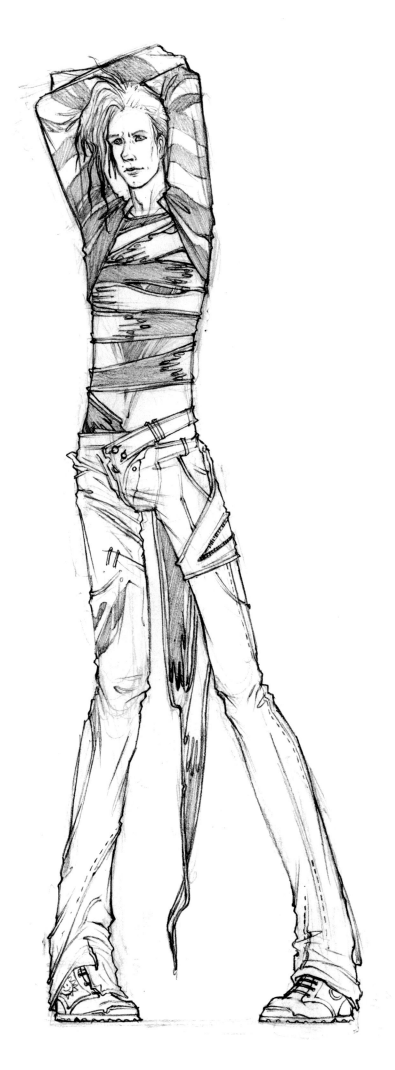

men

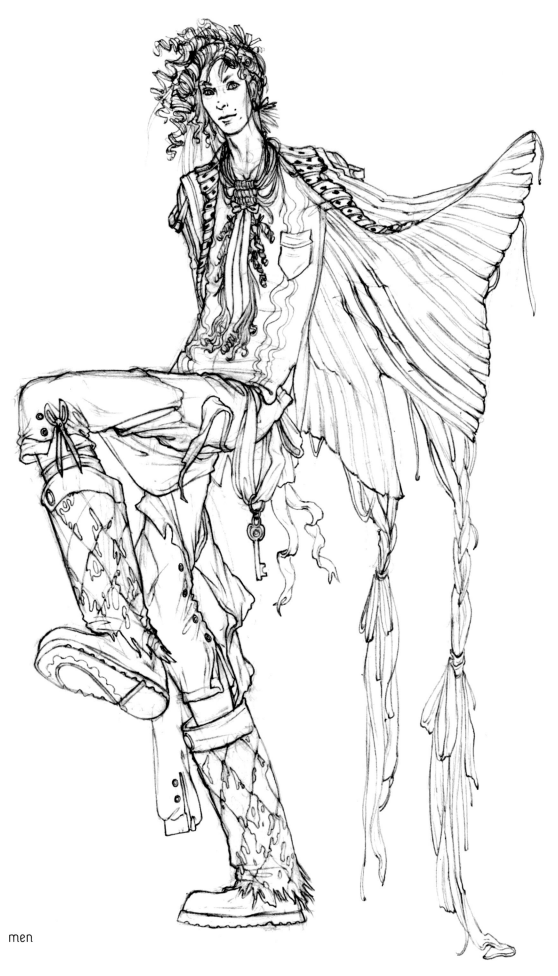

men

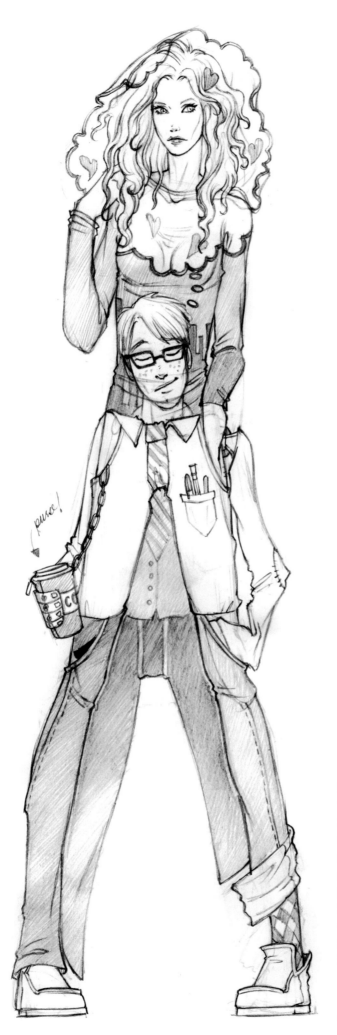

pure!

Daydreaming and Happy Thoughts. This casual wear series includes thought-shaped hoodies. The first one I did was the guy thinking of the girl, then the rest followed: A girl dreaming about her favorite pet, a boy thinking of what he's drawing, a lion thinking of what's for dinner, and a librarian who's fantasizing.

thought-shaped hoodies

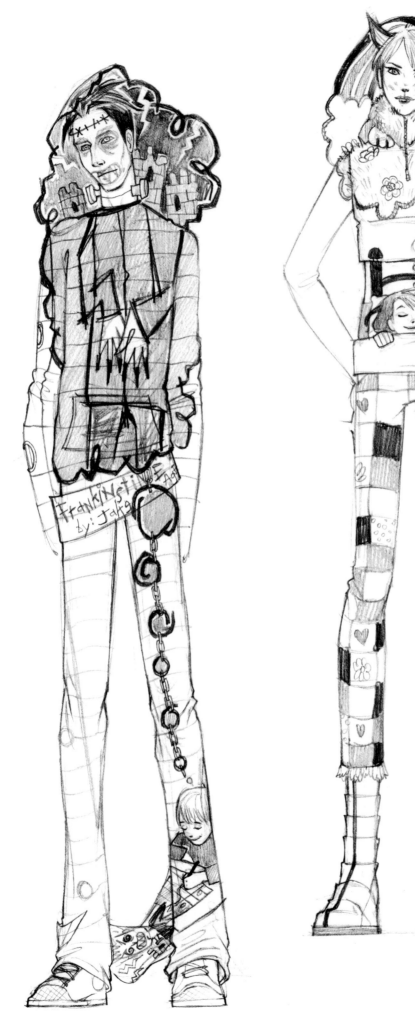

thought-shaped hoodies

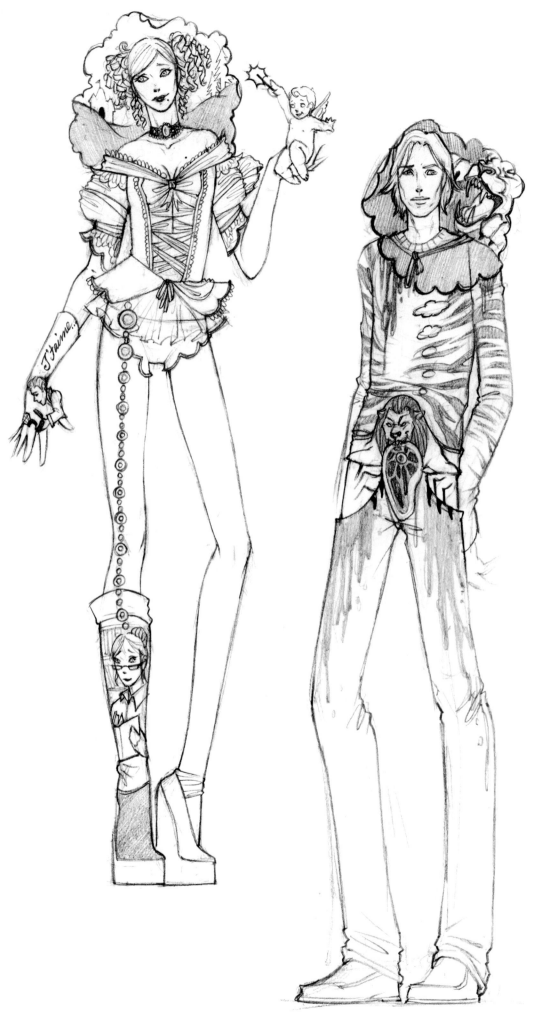

thought-shaped hoodies

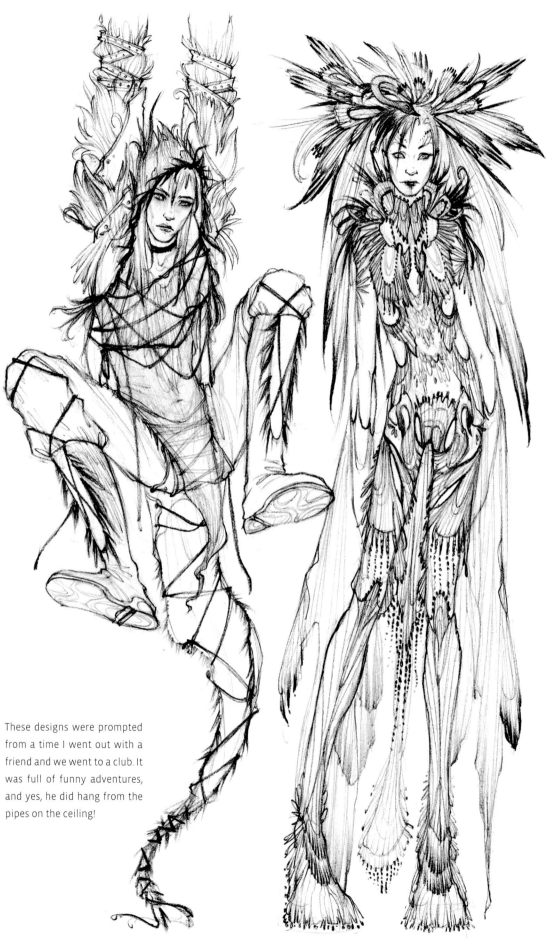

These designs were prompted from a time I went out with a friend and we went to a club. It was full of funny adventures, and yes, he did hang from the pipes on the ceiling!

fashnessclubdess

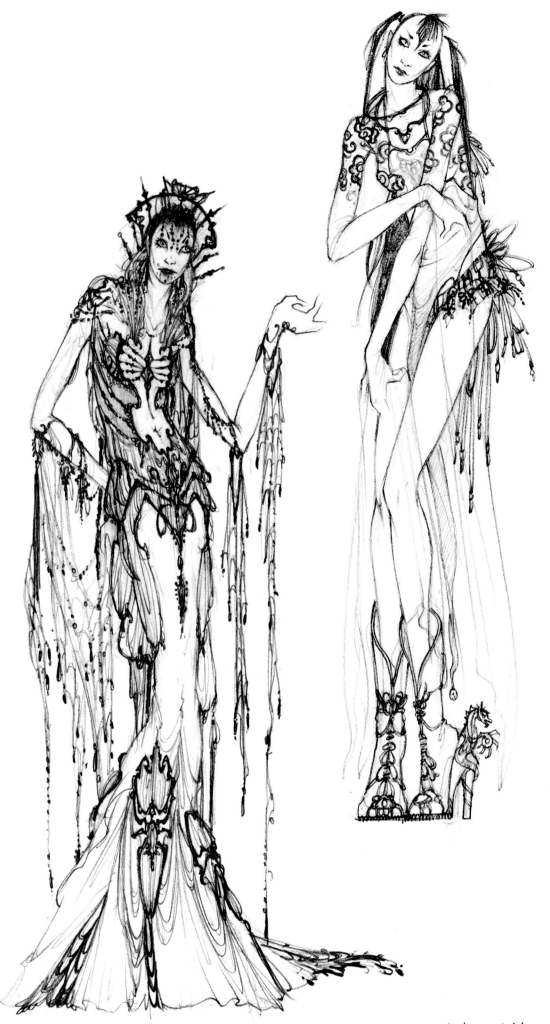

fashnessclubdess

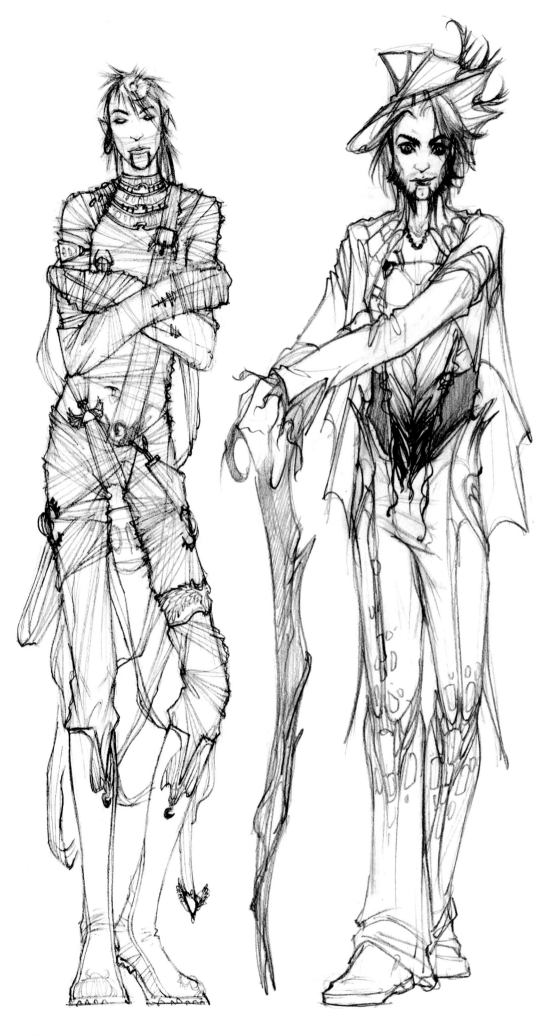

fashnessclubdess

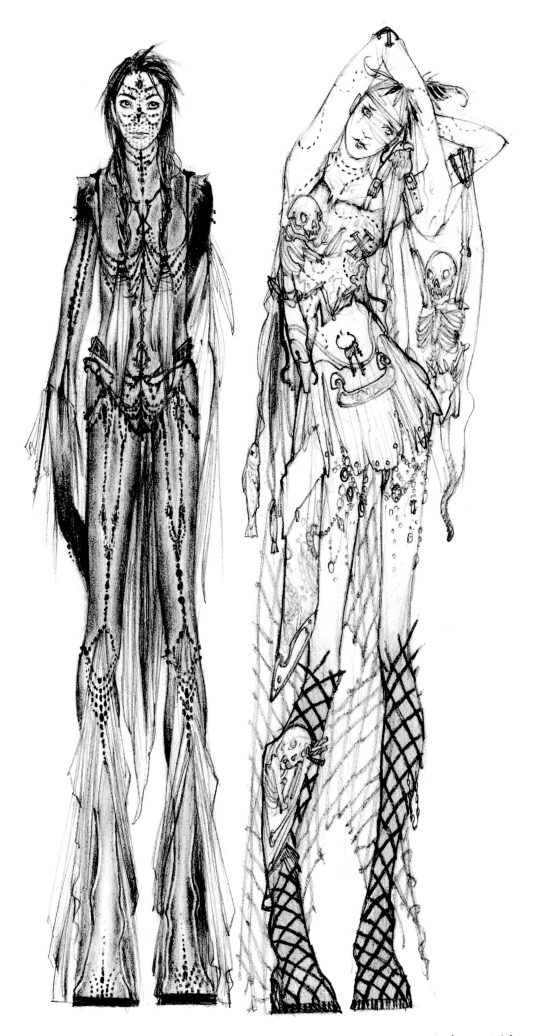

fashnessclubdess

31

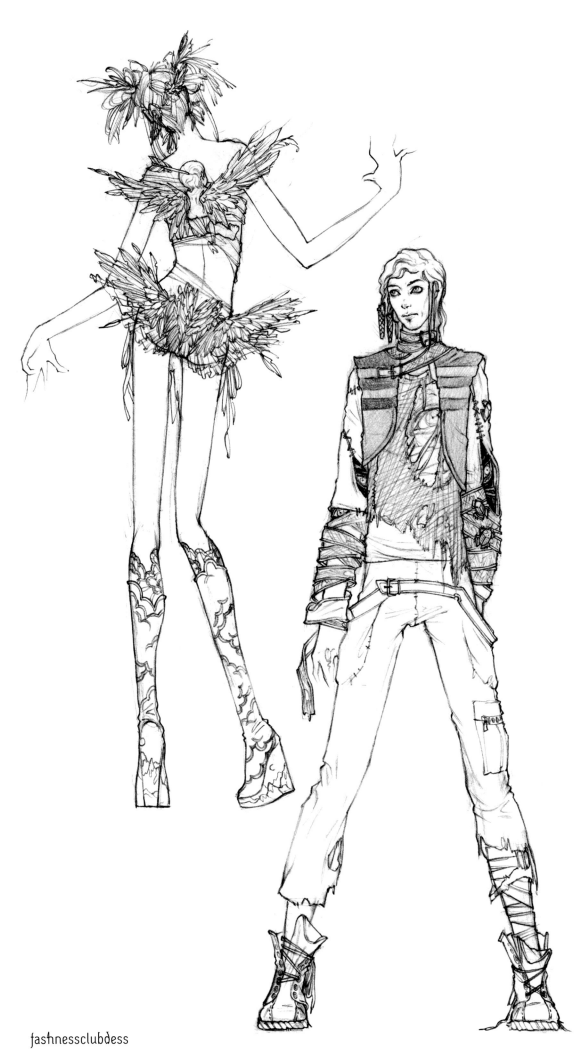

fashnessclubdess

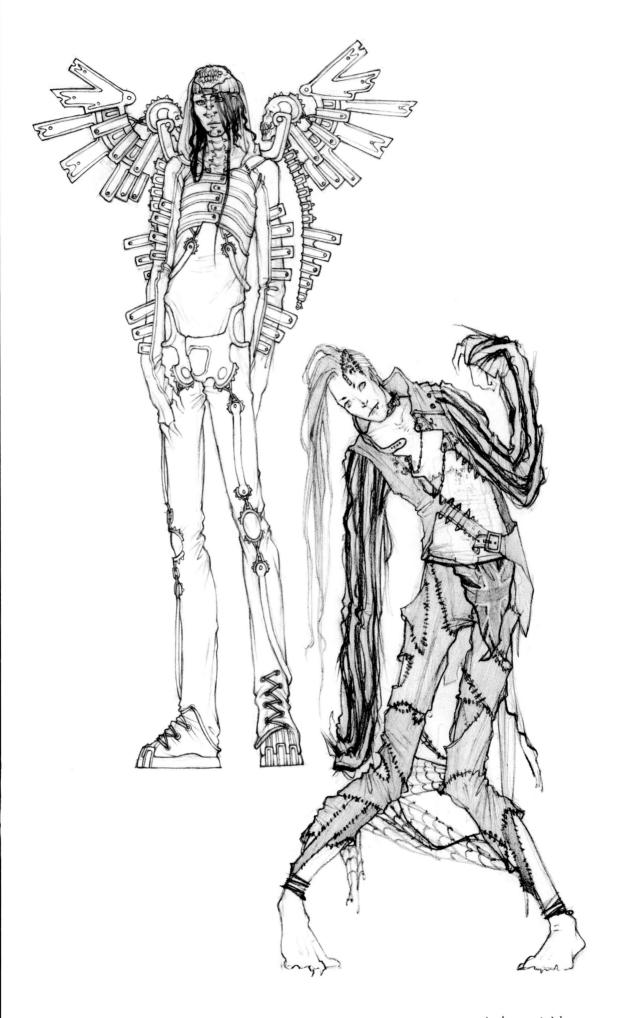

fashnessclubdess

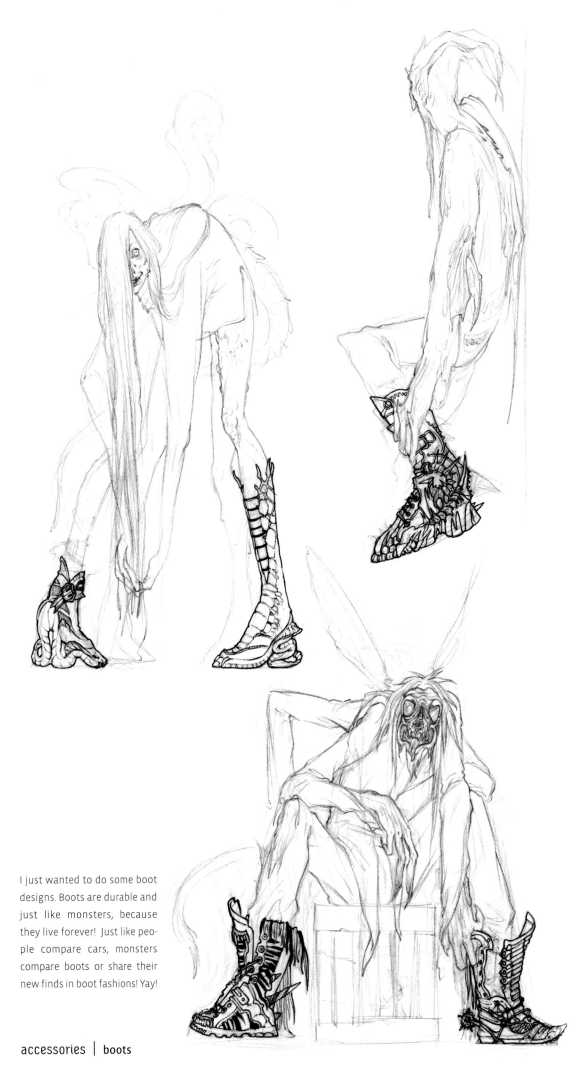

I just wanted to do some boot designs. Boots are durable and just like monsters, because they live forever! Just like people compare cars, monsters compare boots or share their new finds in boot fashions! Yay!

accessories | boots

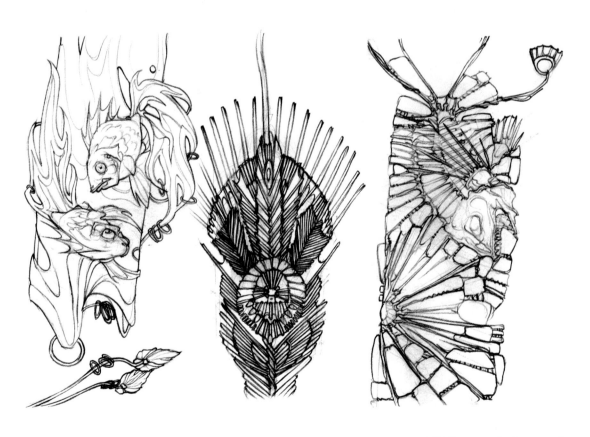

I did these one day because at
one time I was obsessed with
leather cuffs.

accessories | cuffs

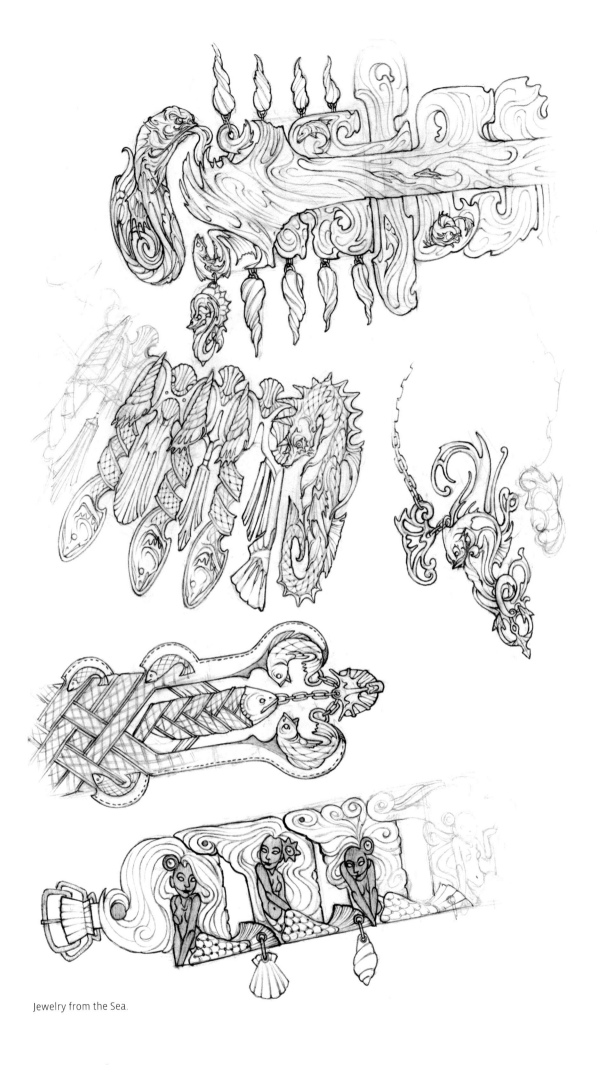

Jewelry from the Sea.

accessories | jewelry

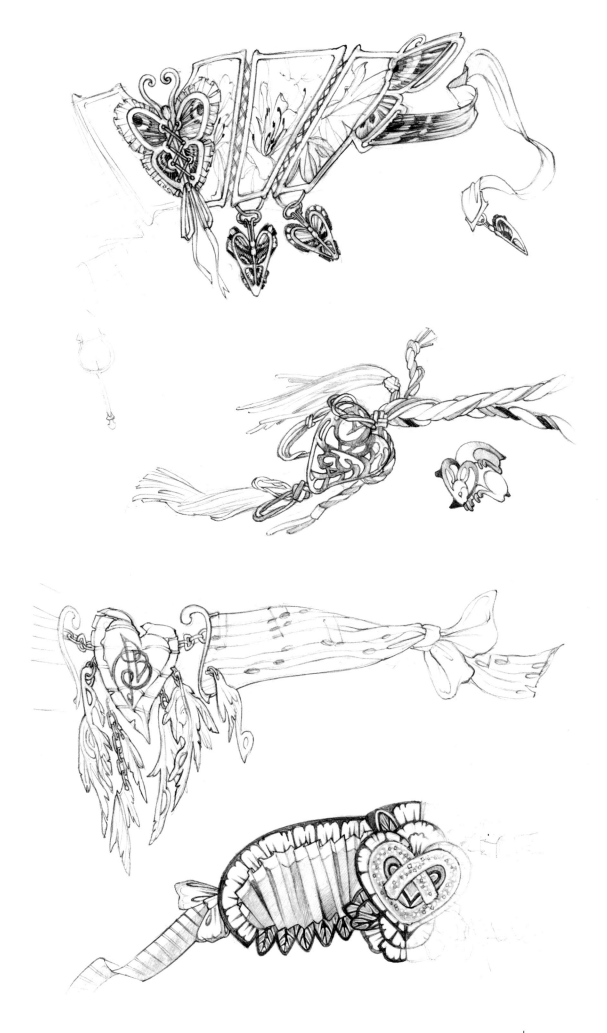

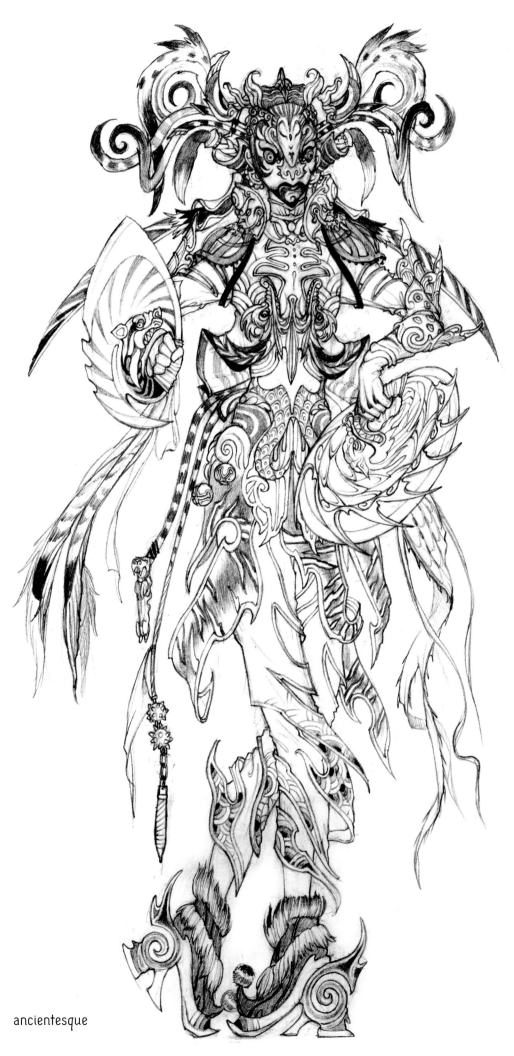

ancientesque

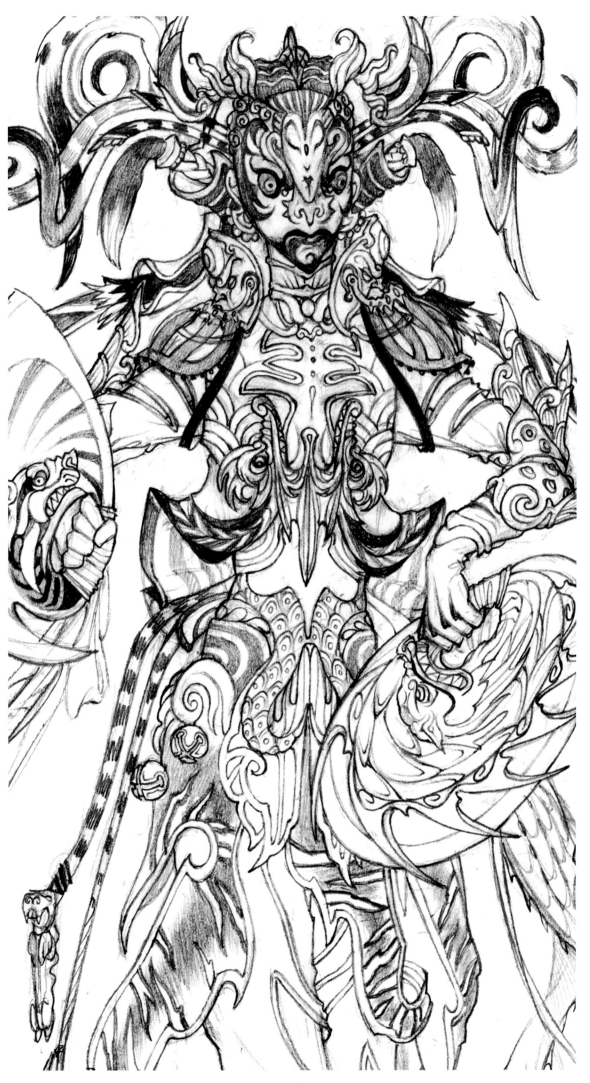

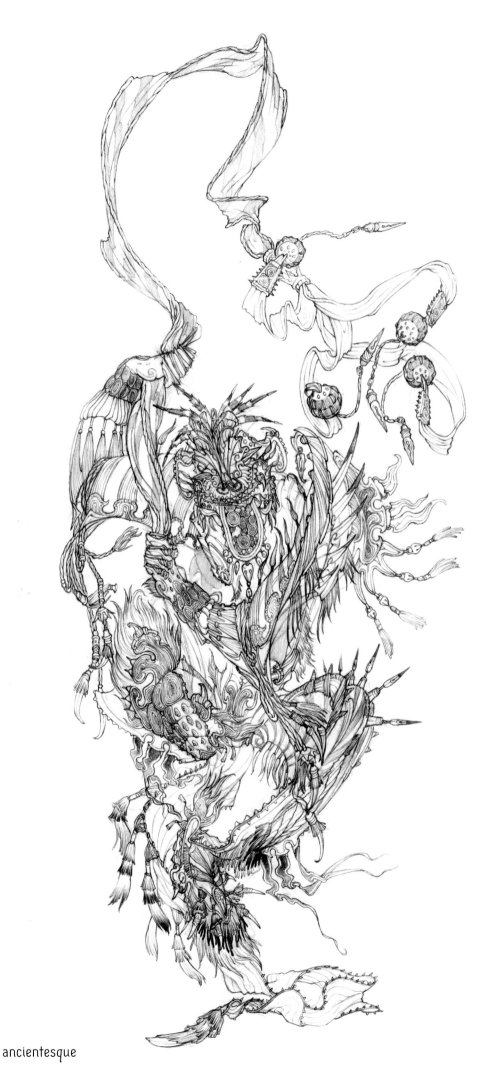

ancientesque

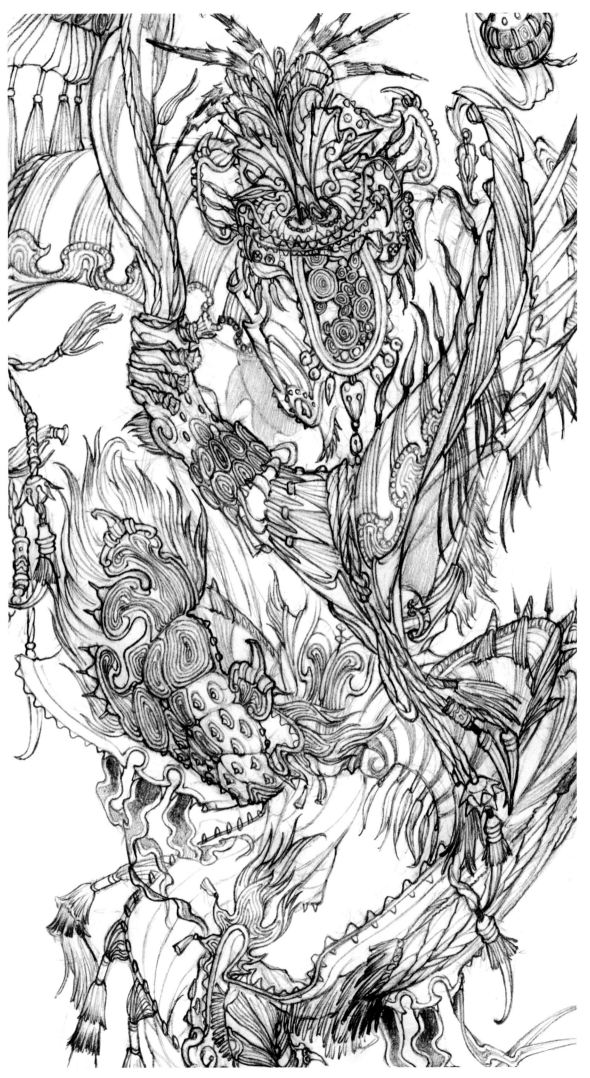

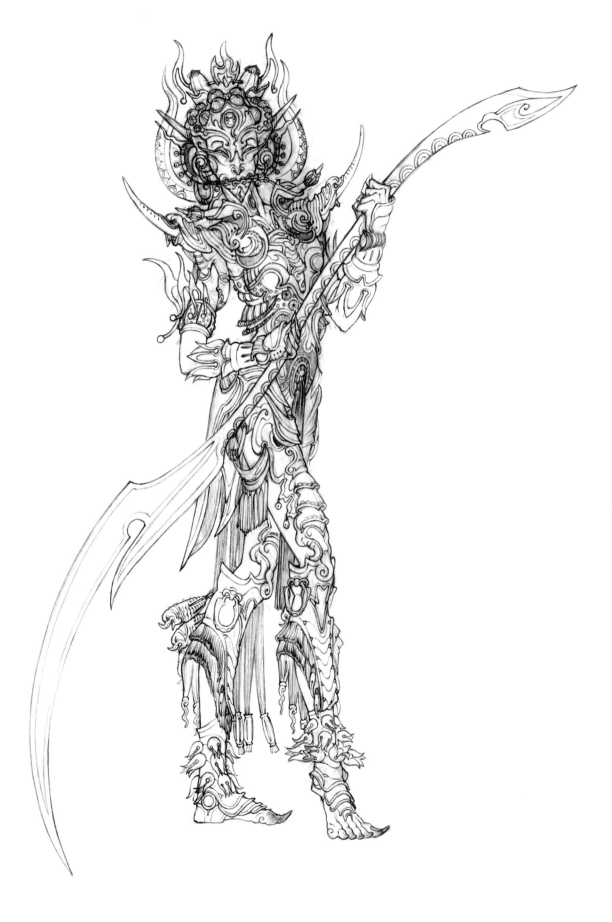

ancientesque

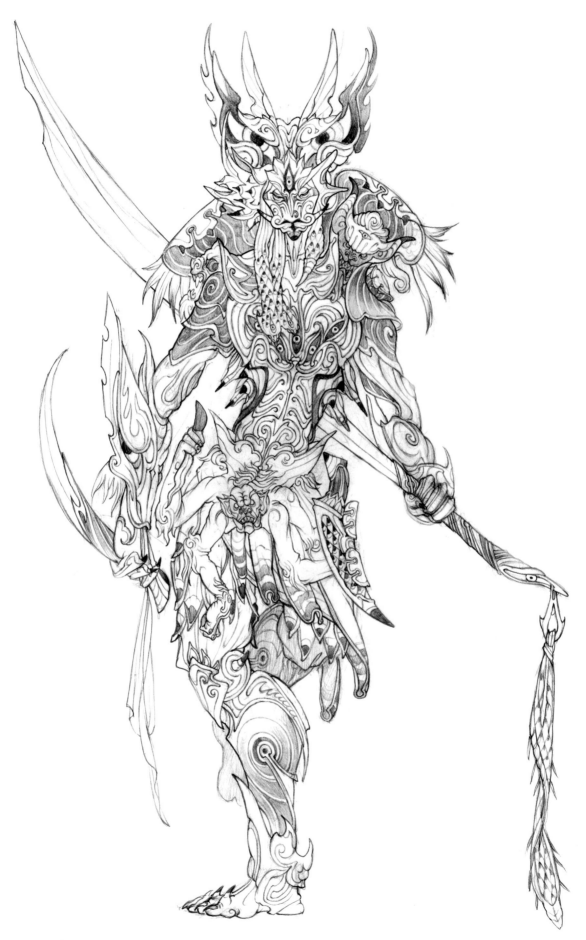

ancientesque

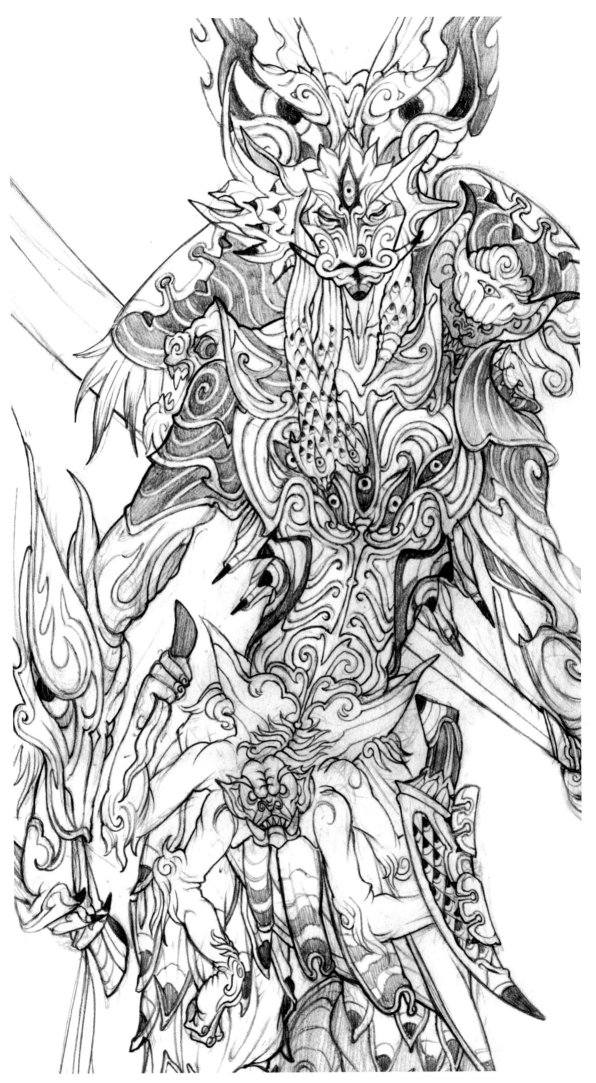

2 animals

These animals are made up of bits and pieces of things I would like to have as a pet. Some of them are just for fun, to see what an animal would look like if it was put in some weird situation. Some of them are just excuses to design accessories or fashion bits!

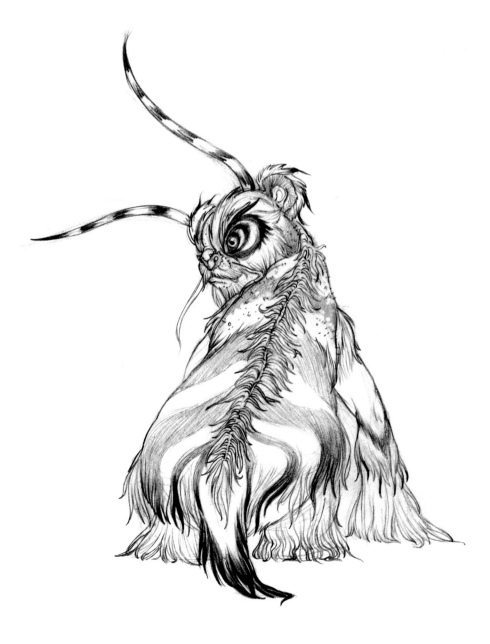

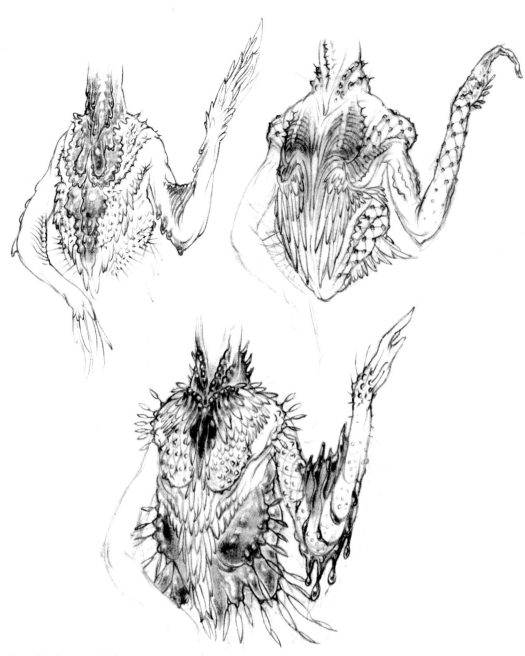

I thought frozen chickens would be interesting to draw. Why not? They are stubby little things and have comical proportions, yet they have this secret elegance to them. Then I thought, "Ballet dancers are graceful things, maybe my frozen chickens can learn something from them!" The BwakBwaks were born. They have thick, flexible skin, so instead of leaving them naked, I made them elegant clothes. If a BwakBwak were really alive, it would be all covered in feathers, so I sewed up their skin and added some feathers that they can wear!

bwakbwak ballet

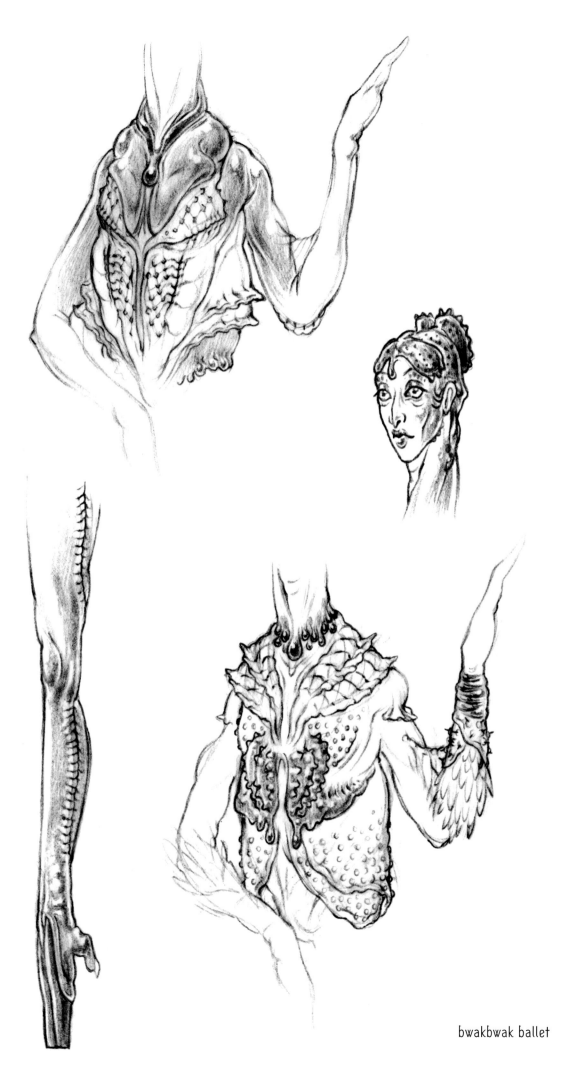

bwakbwak ballet

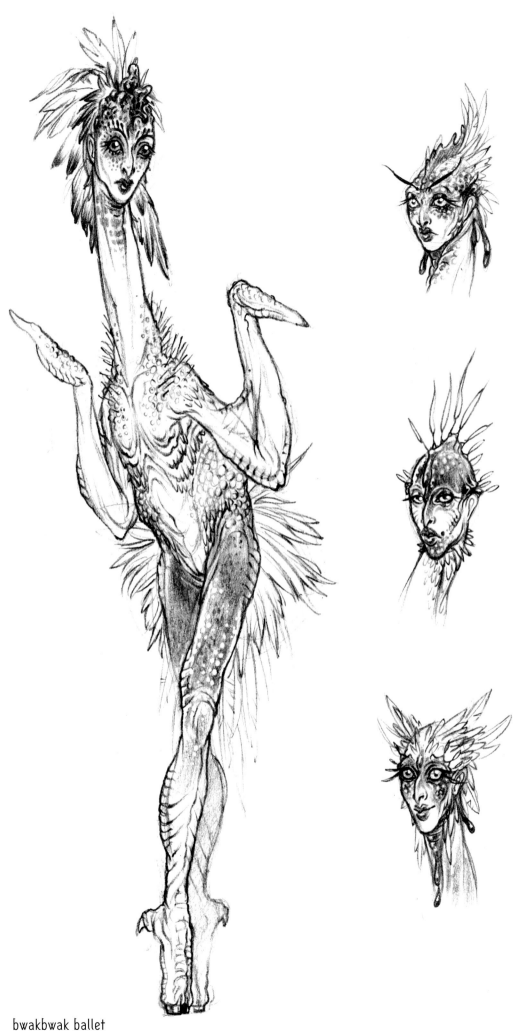

bwakbwak ballet

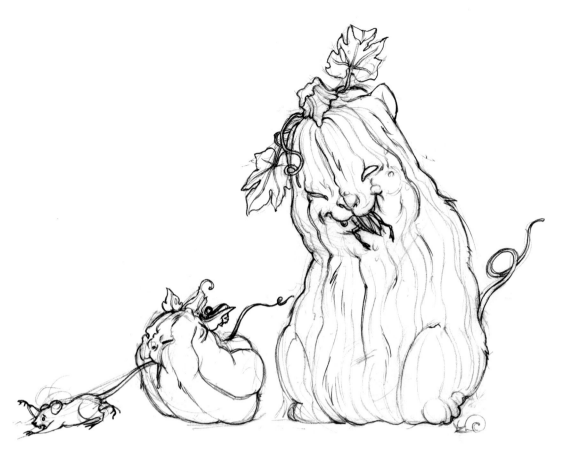

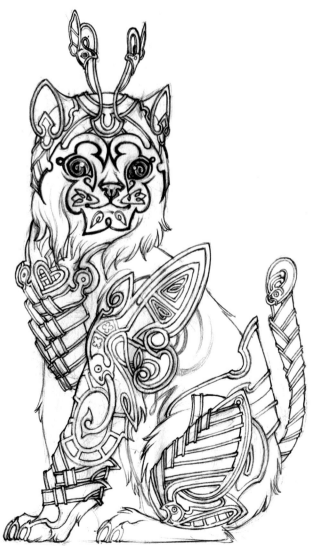

When I was younger, I always wanted a cat, but couldn't have one. So one day, I just started drawing some really different cats. At first they were a bit serious, then they evolved into a wide array of cats: different cats for different moods and activities! Plus, real cats are just sort of there. I thought it would be more fun if the cats I drew were more than just decorated, they had different concepts!

concept cats | pumpkin celtic

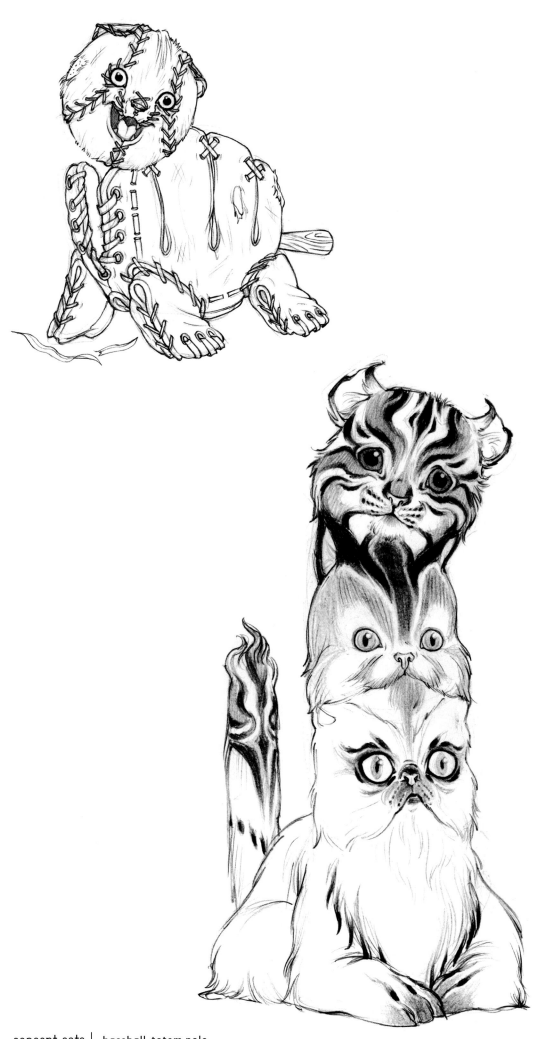

concept cats | baseball totem pole

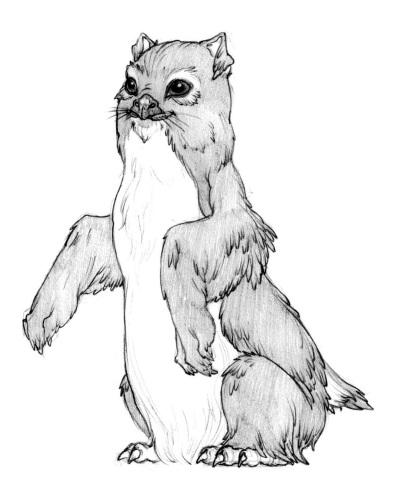

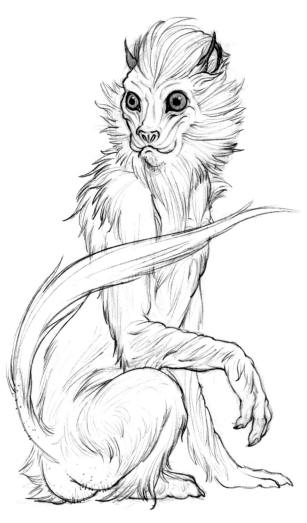

concept cats | penguin baboon

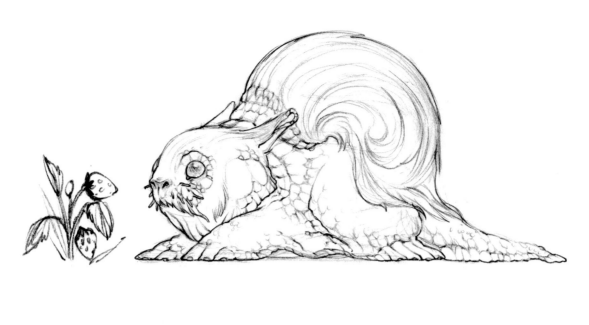

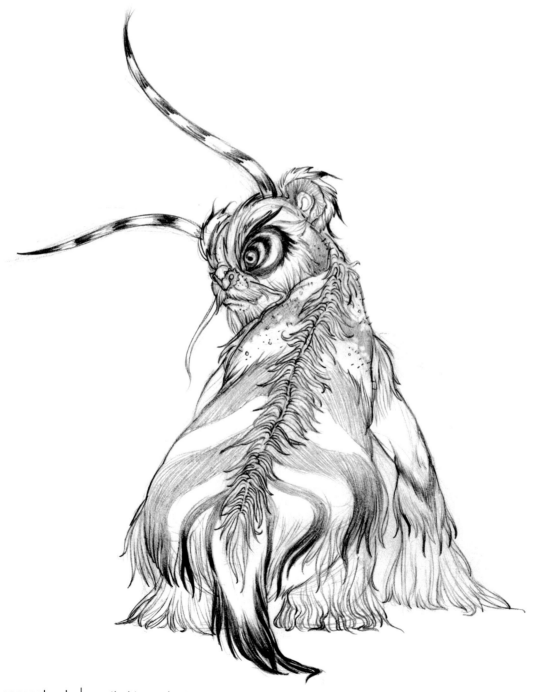

concept cats | snail chinese dragon

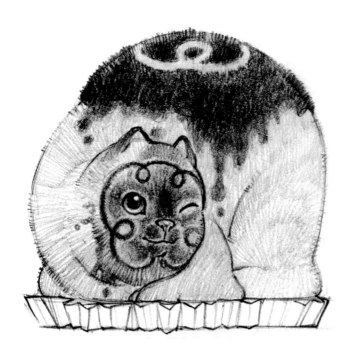

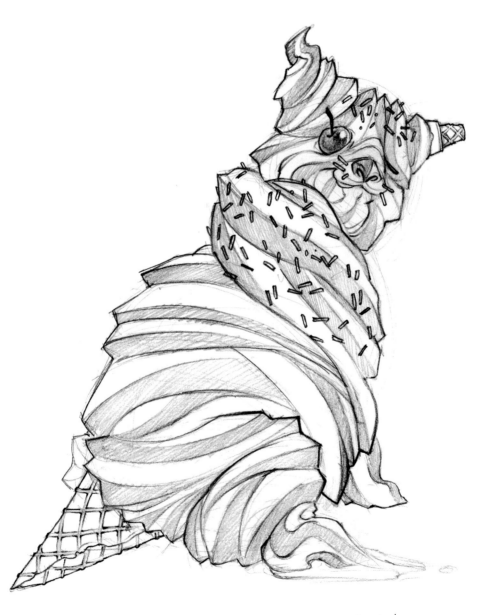

concept cats | bon bon ice cream cone

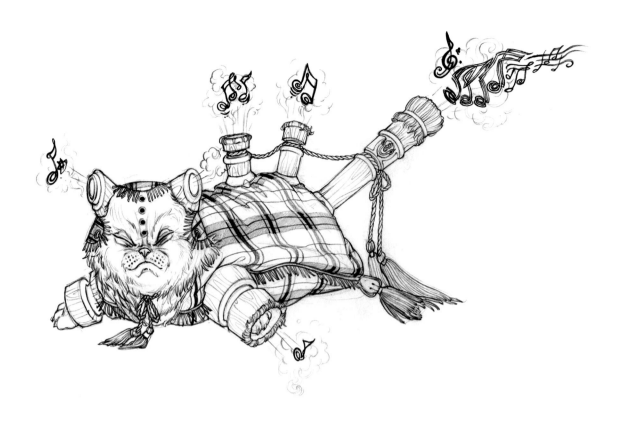

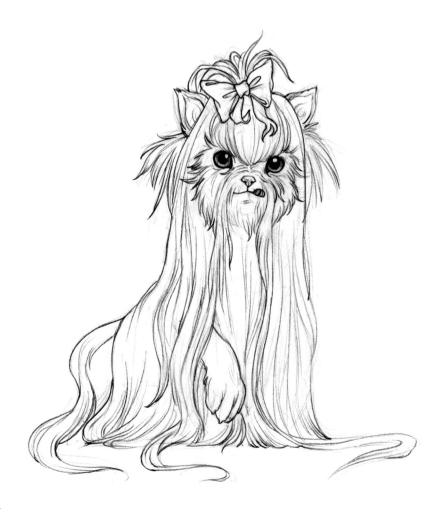

concept cats | bagpipe yorkshire terrier

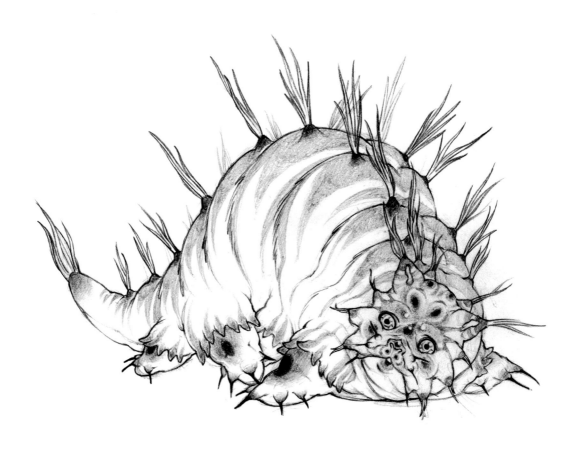

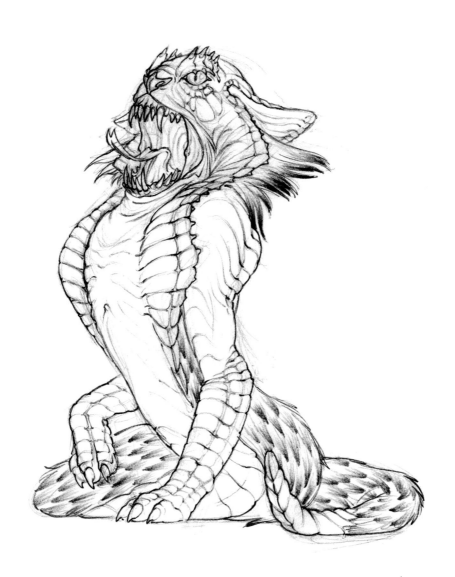

concept cats | caterpillar snake

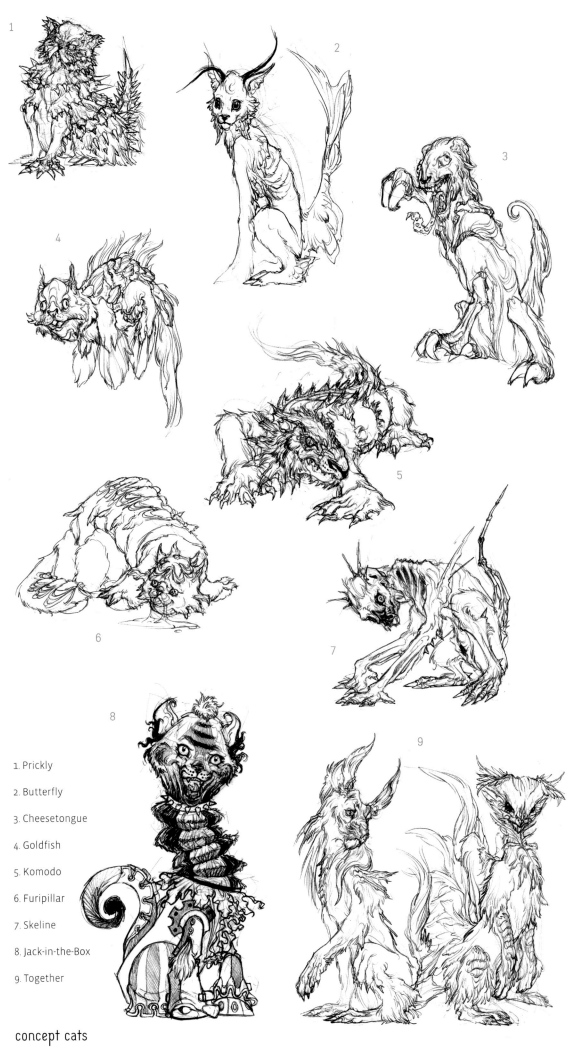

1

2

3

4

5

6

7

8

9

1. Prickly

2. Butterfly

3. Cheesetongue

4. Goldfish

5. Komodo

6. Furipillar

7. Skeline

8. Jack-in-the-Box

9. Together

concept cats

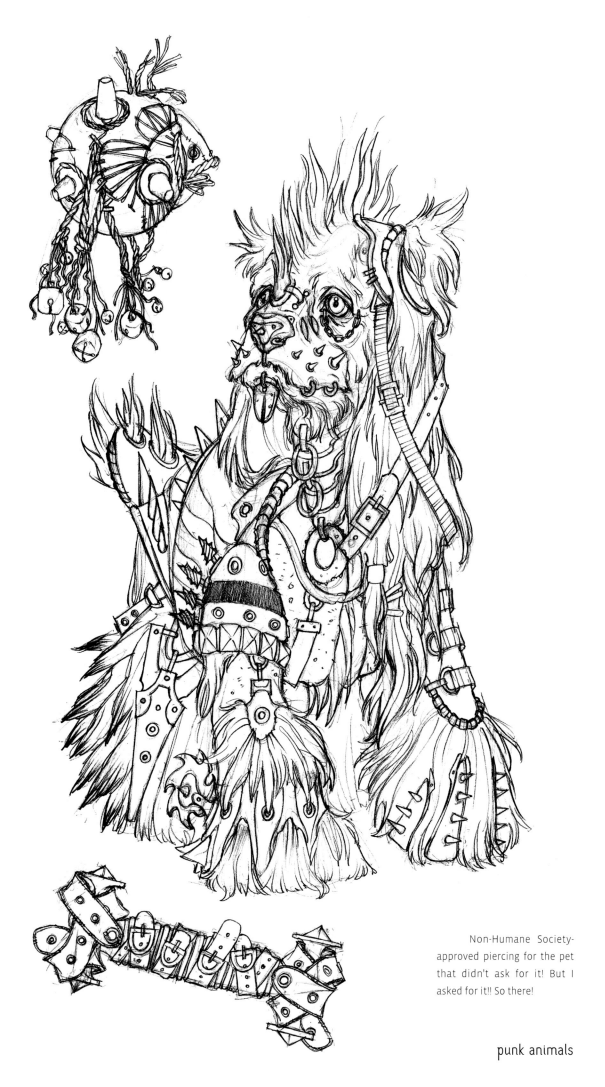

Non-Humane Society-approved piercing for the pet that didn't ask for it! But I asked for it!! So there!

punk animals

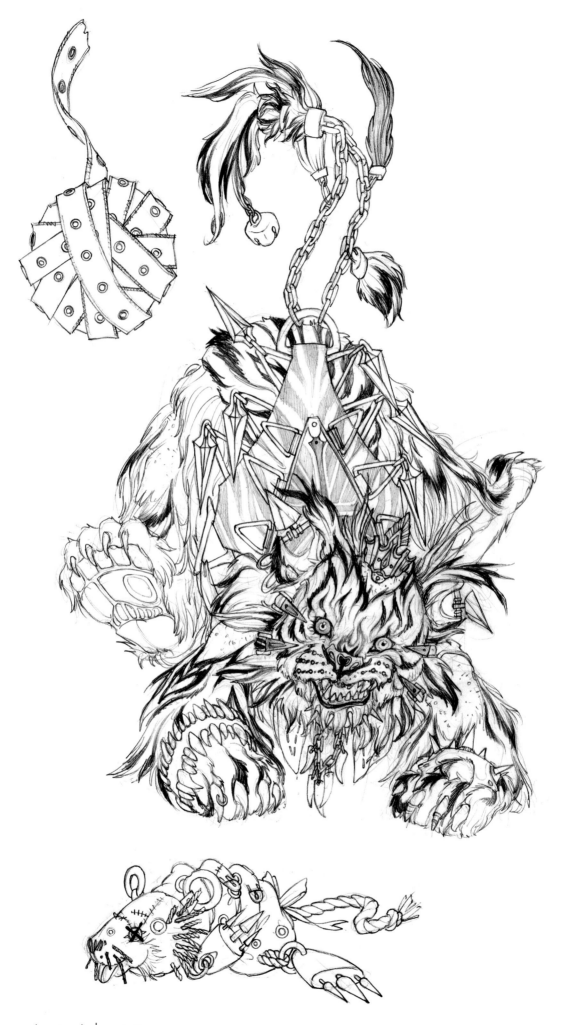

punk animals | punkeline

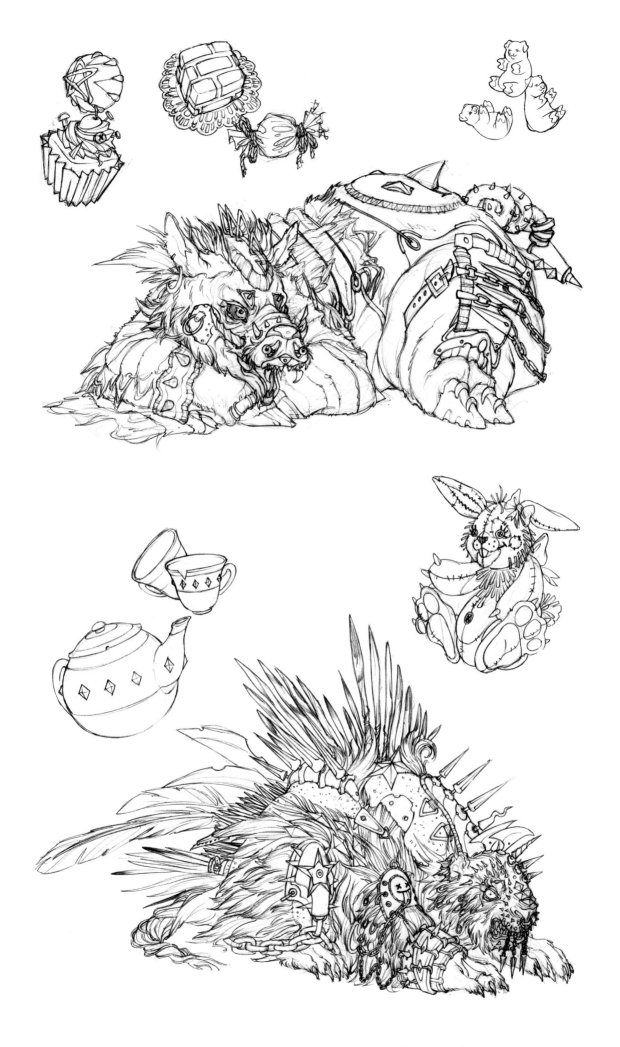

punk animals | punkpork punk-u-pine

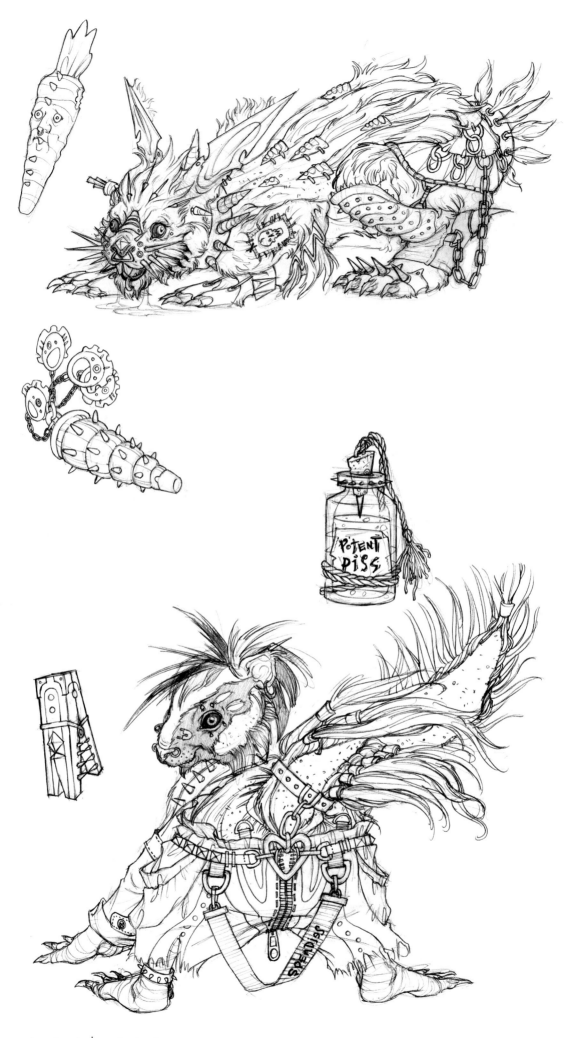

punk animals | punkerbunker skunkupunk

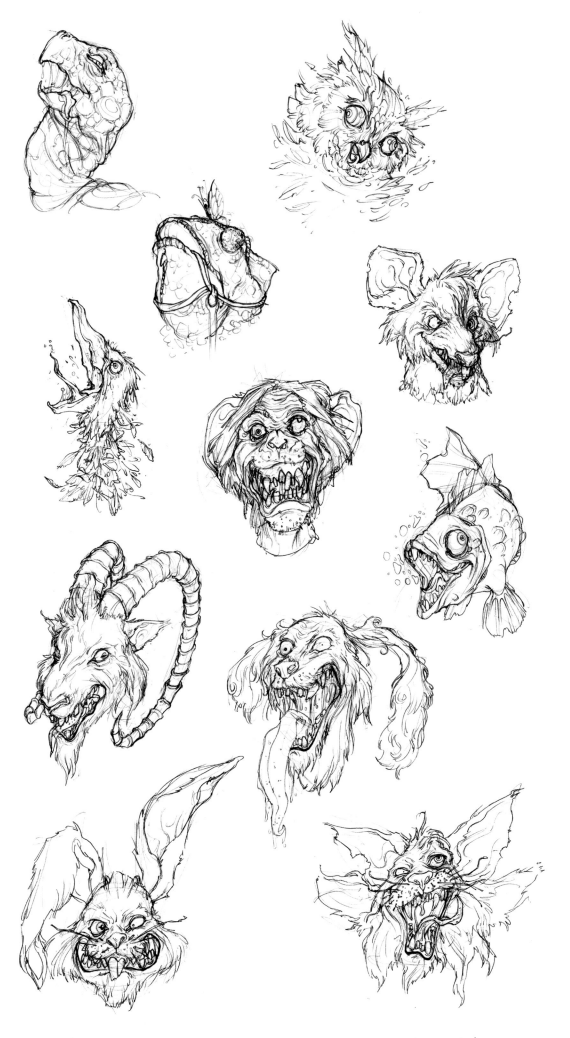

punk animals | rabid animals

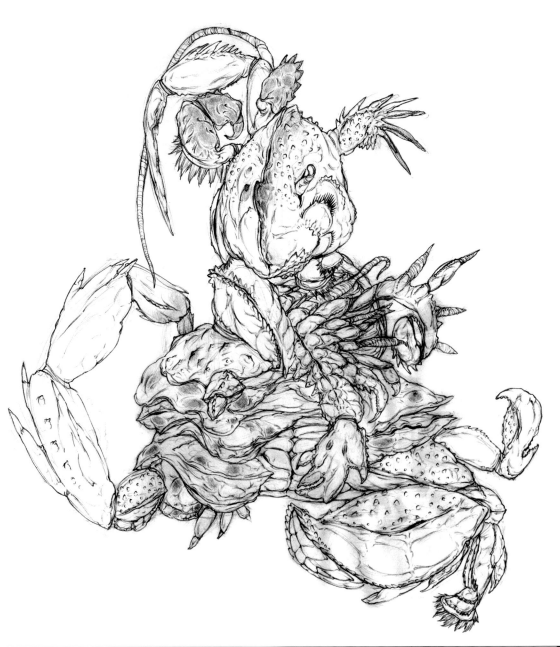

spoiled icons

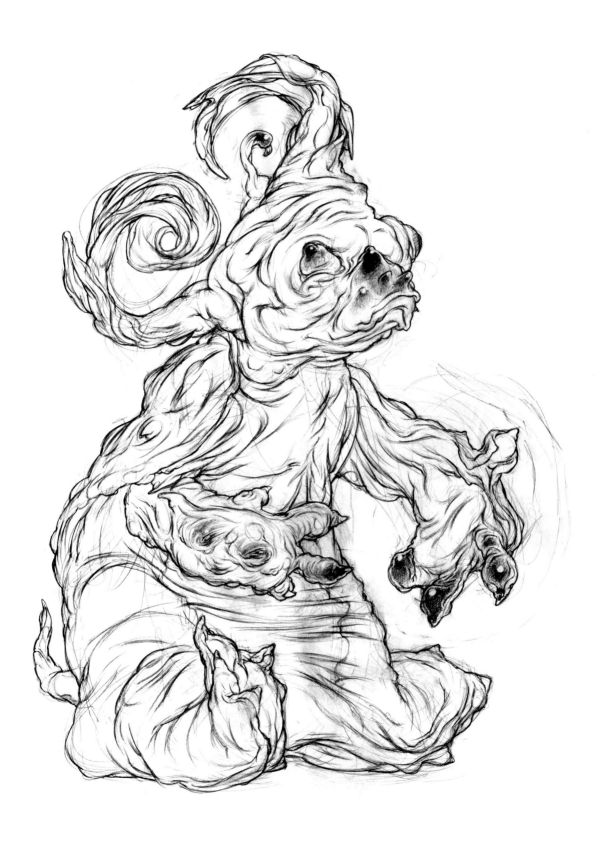

spoiled icons

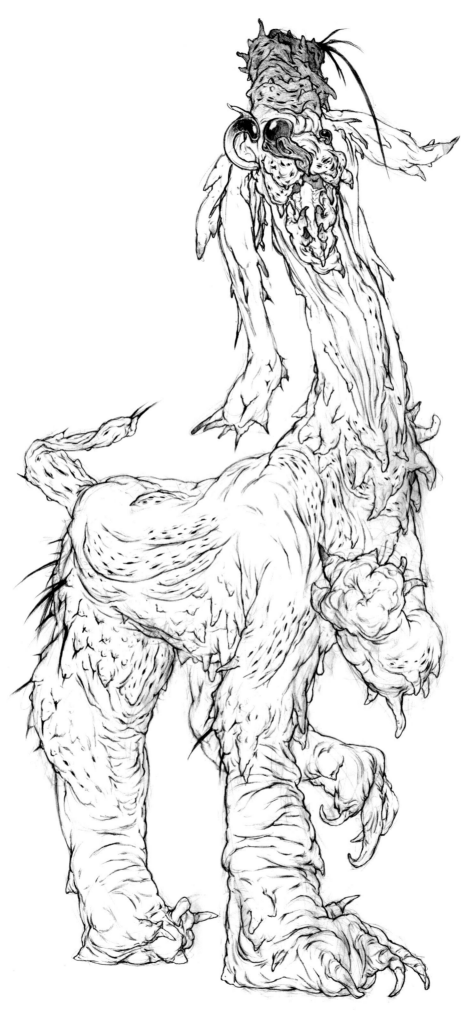

spoiled icons

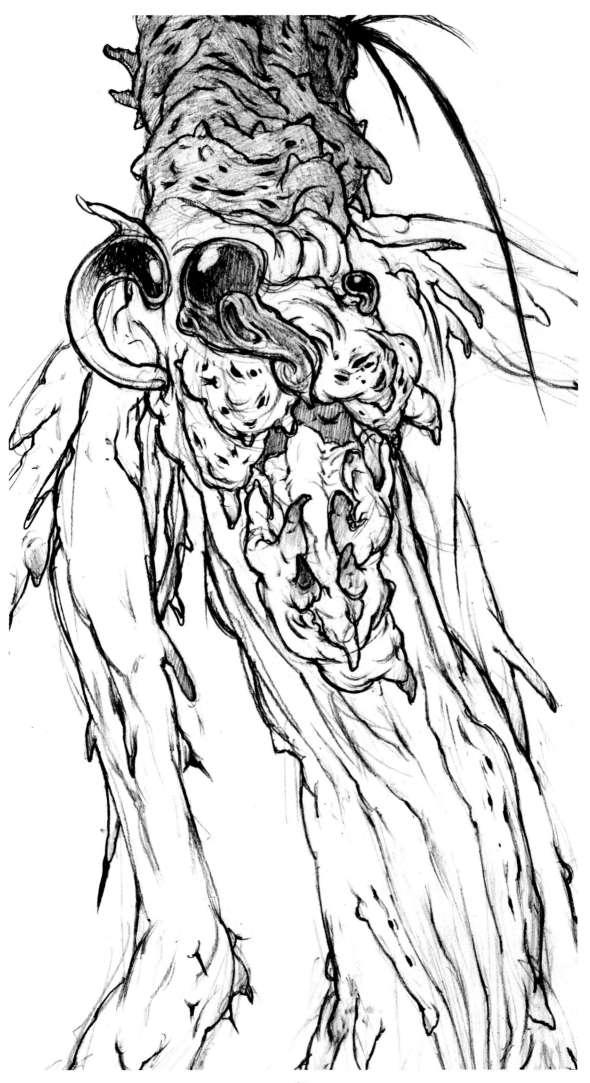

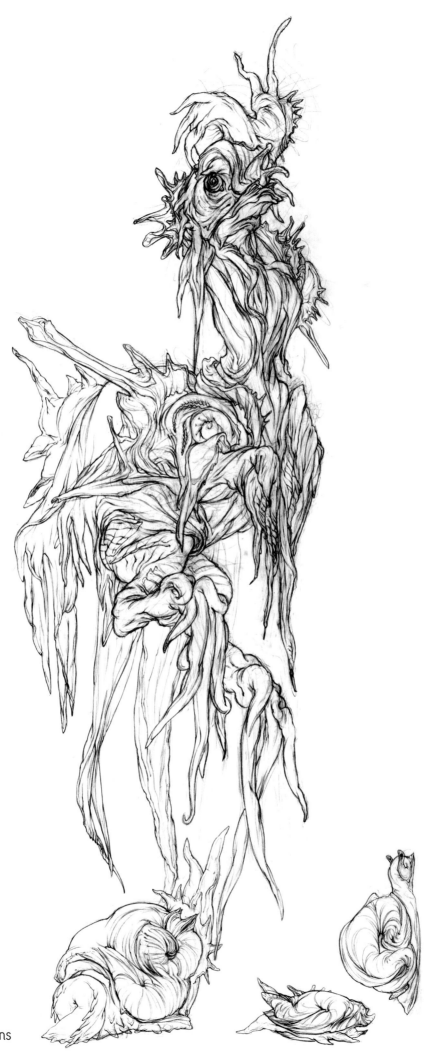

spoiled icons

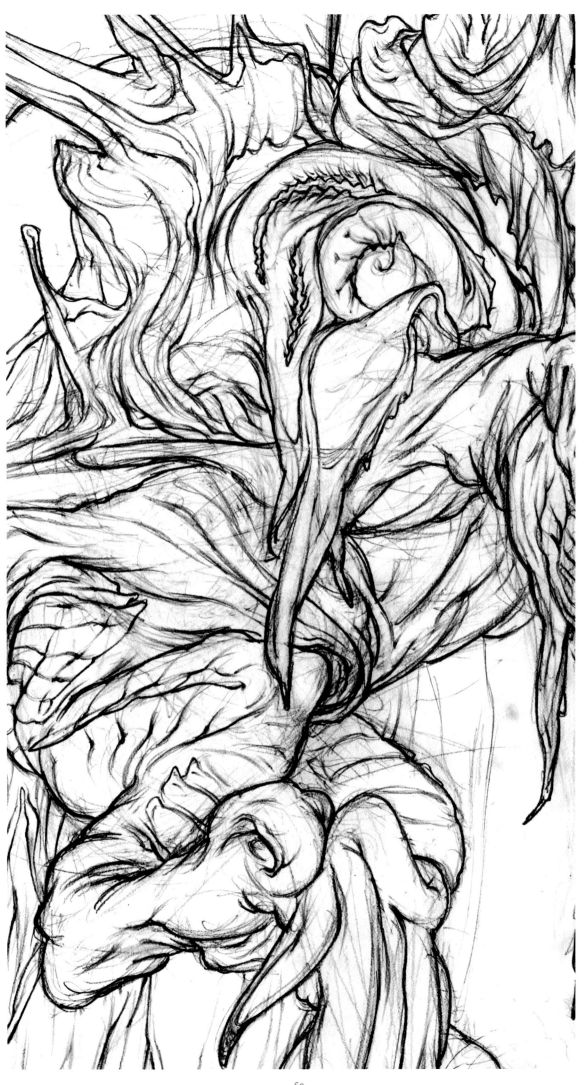

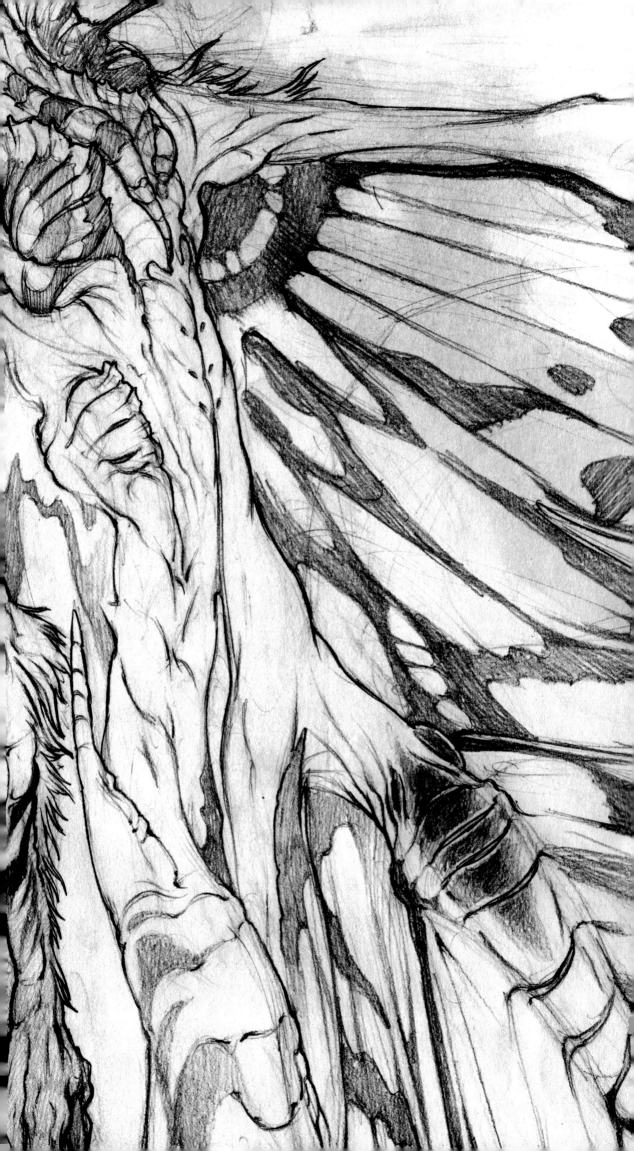

3 INSECT LADIES

One day, I just felt like working on something with insects. Since I was working on the sea-ladies, I decided to do a land version of insect-y creatures.

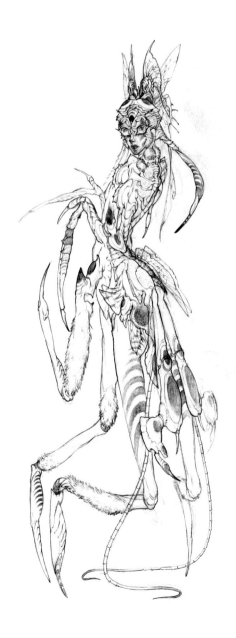

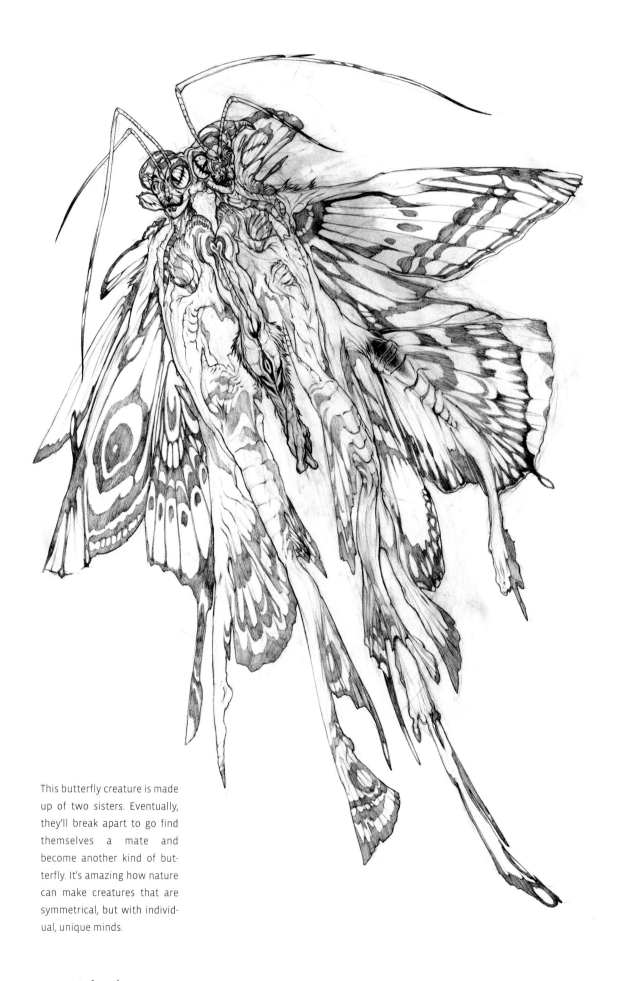

This butterfly creature is made up of two sisters. Eventually, they'll break apart to go find themselves a mate and become another kind of butterfly. It's amazing how nature can make creatures that are symmetrical, but with individual, unique minds.

insect ladies | we are nous

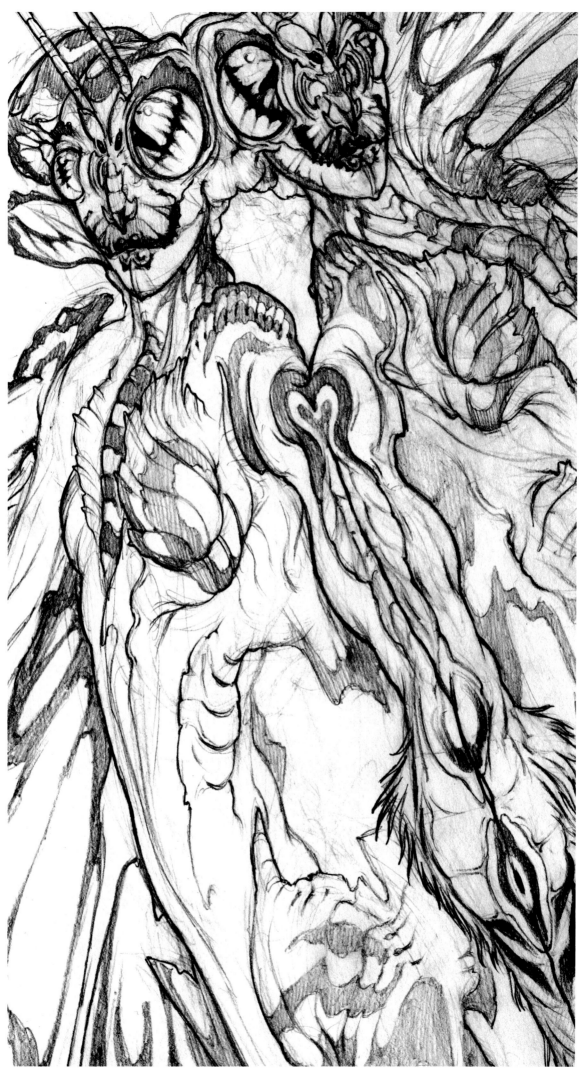

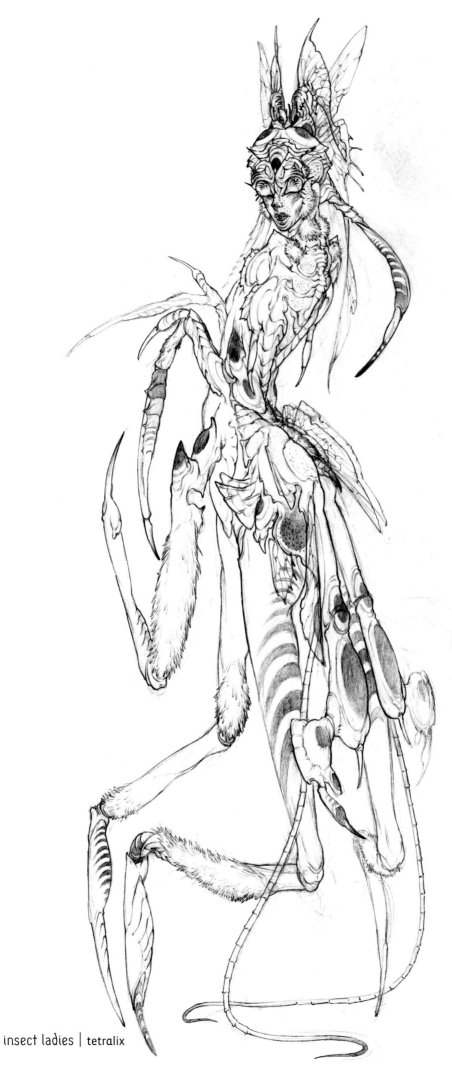

insect ladies | tetralix

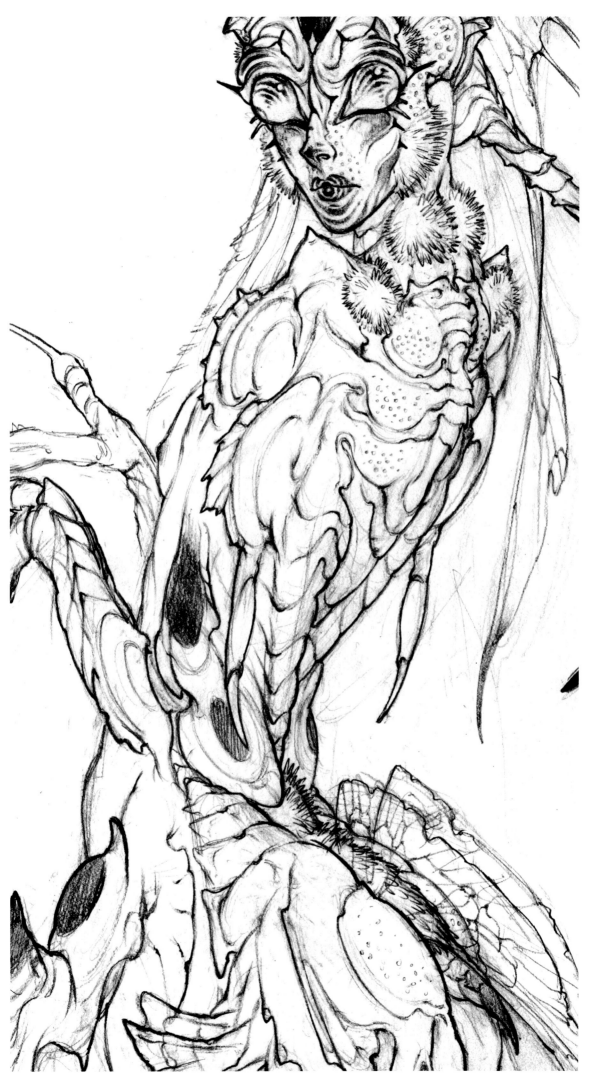

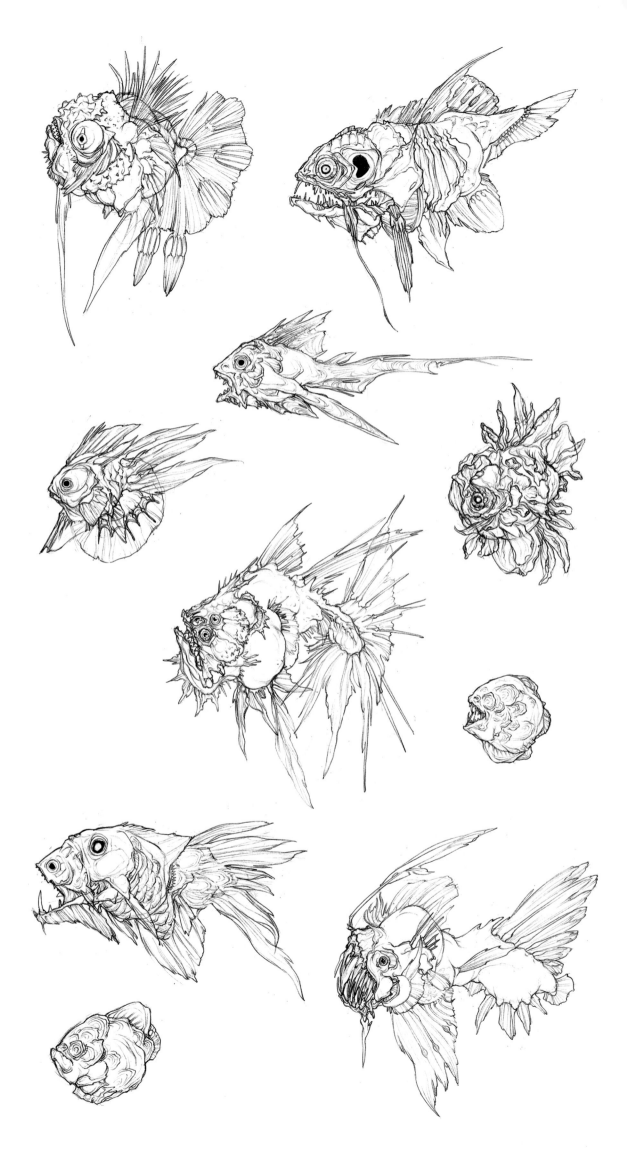

4 SEA CREATURE LADIES

One day, Spyrusia formed herself in my brain, and the rest of her friends just sort of followed. They are a mix of all sorts of things from the sea-a sort of seafood stew if you will! To form these ladies, I would choose a central image or a creature from the sea and add bits of other objects.

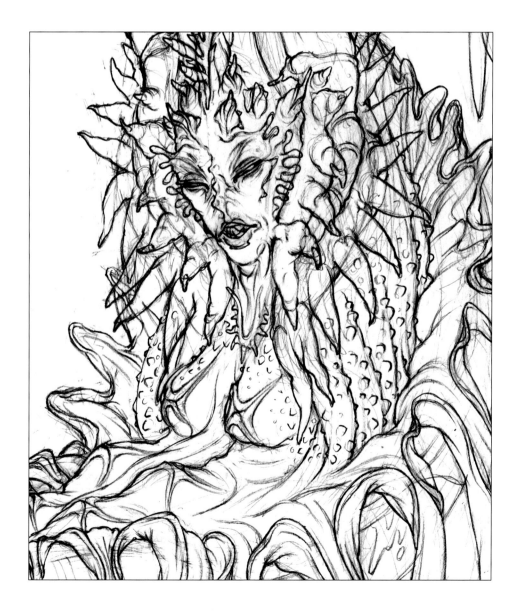

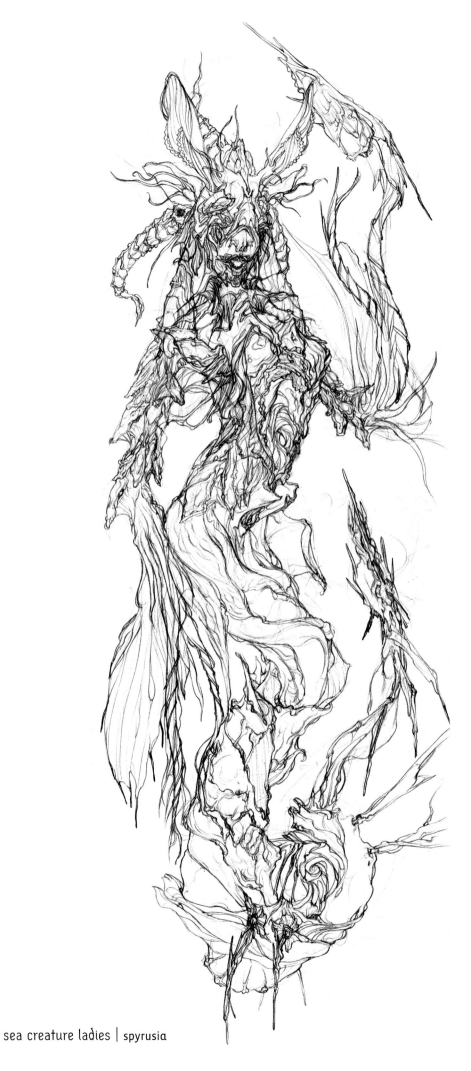

sea creature ladies | spyrusia

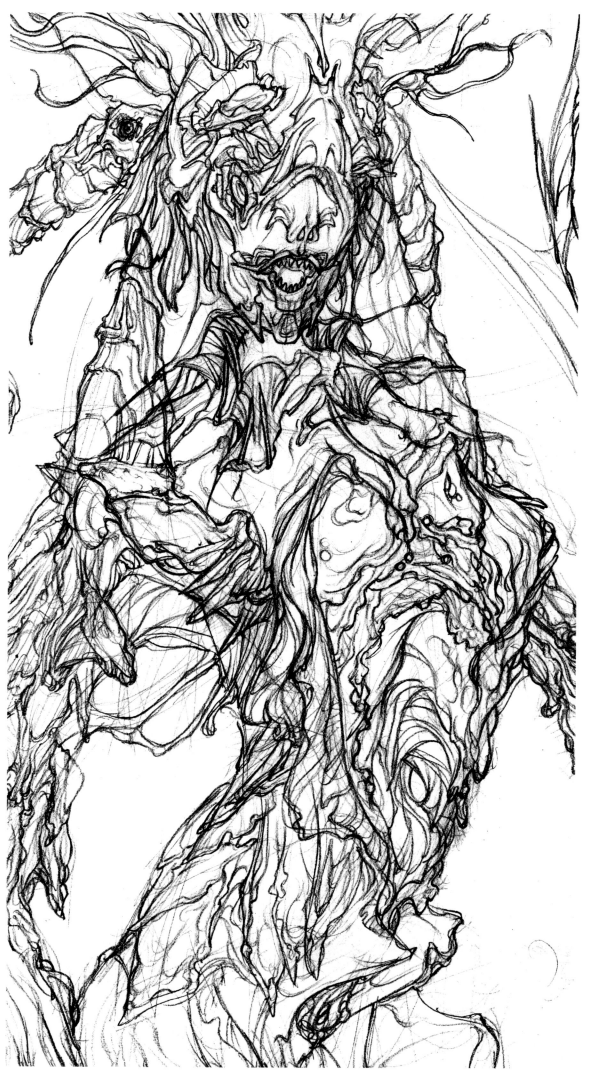

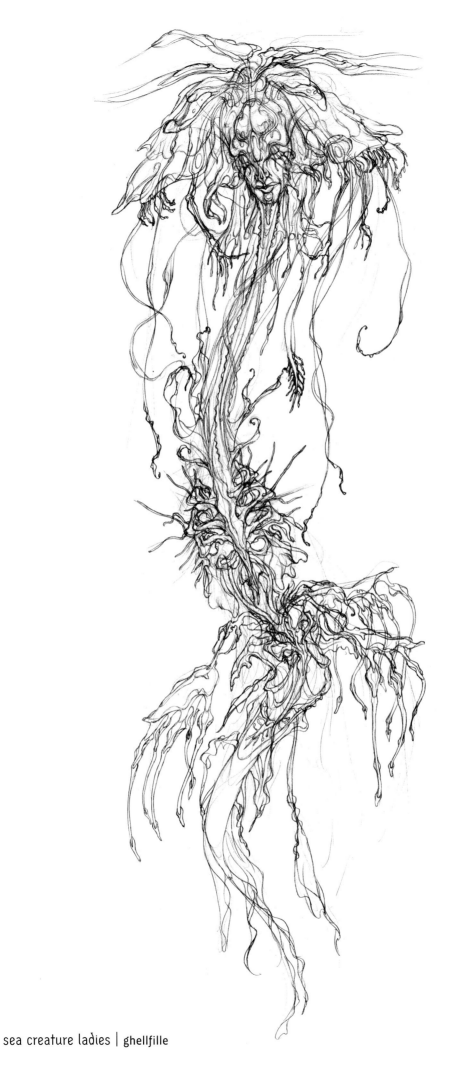

sea creature ladies | ghellfille

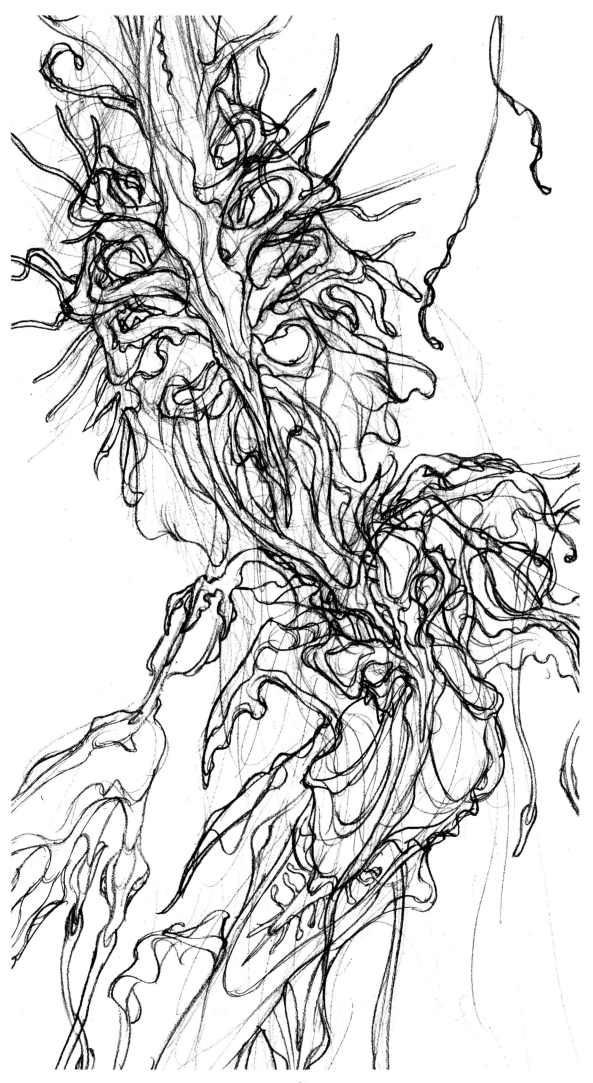

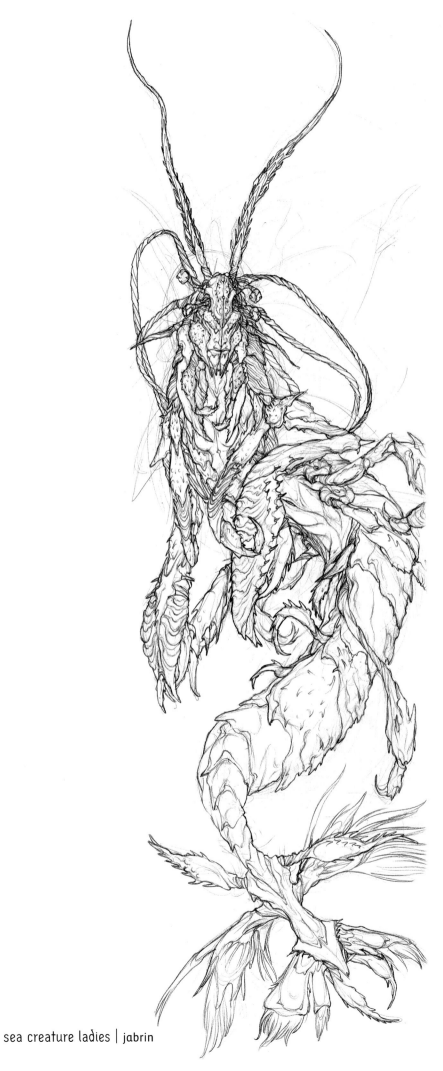

sea creature ladies | jabrin

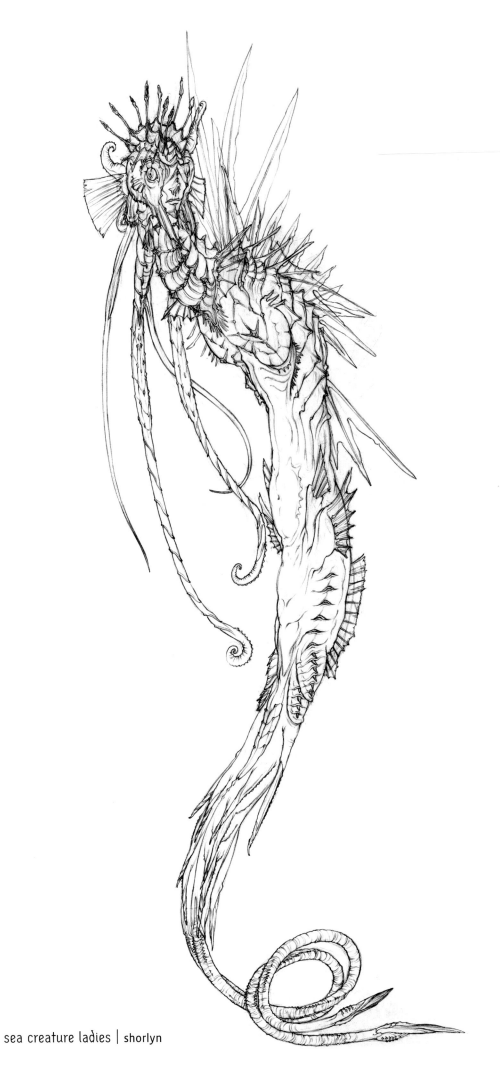

sea creature ladies | shorlyn

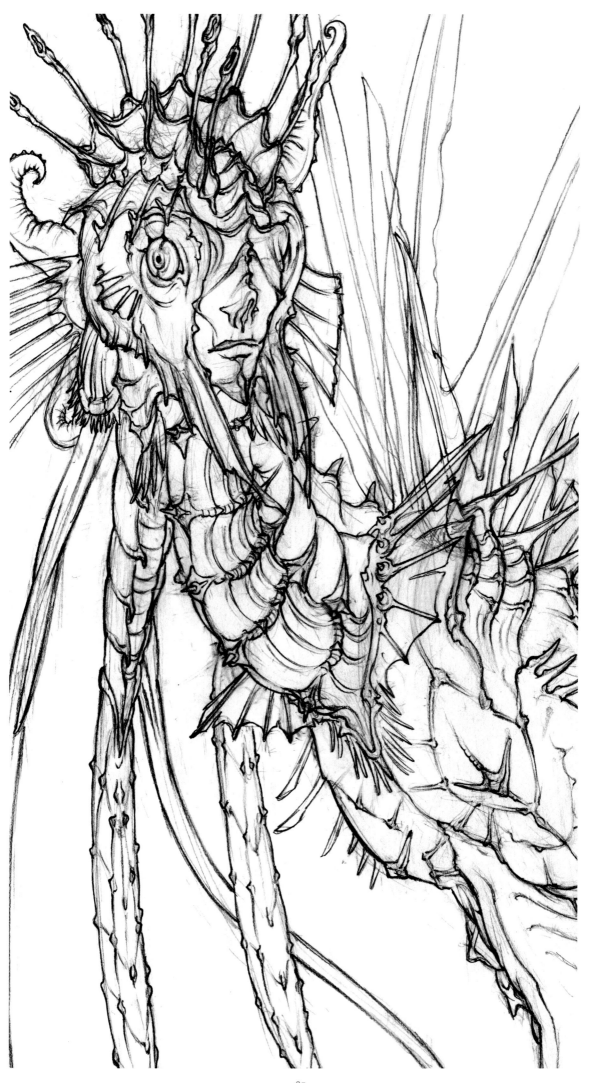

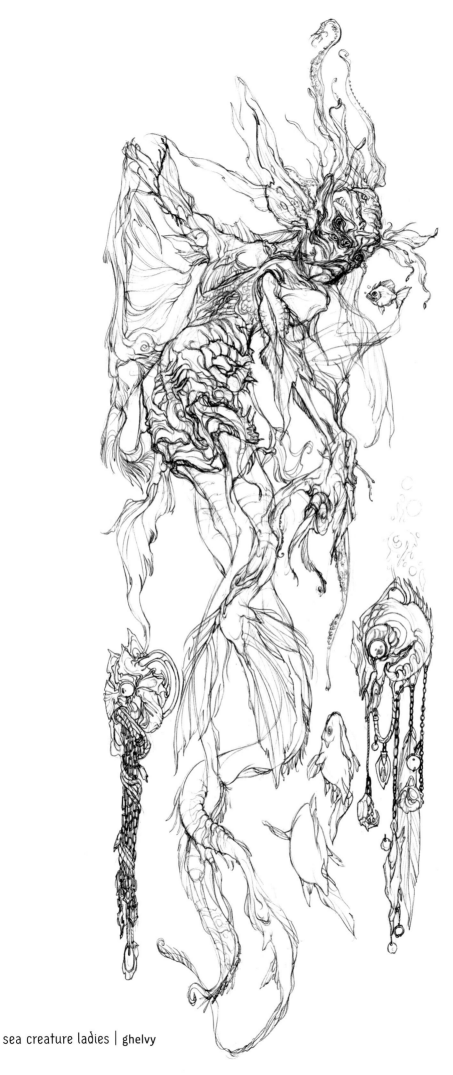

sea creature ladies | ghelvy

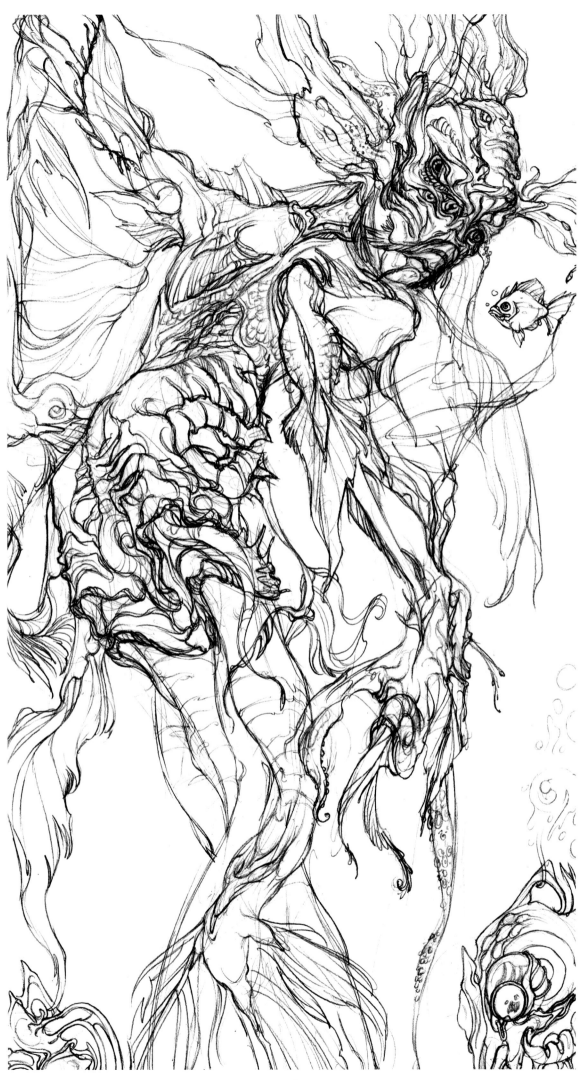

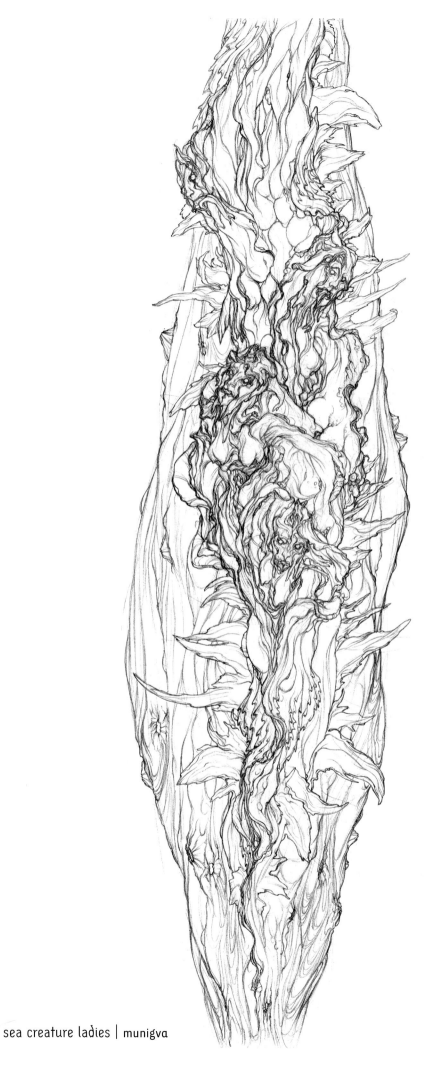

sea creature ladies | munigva

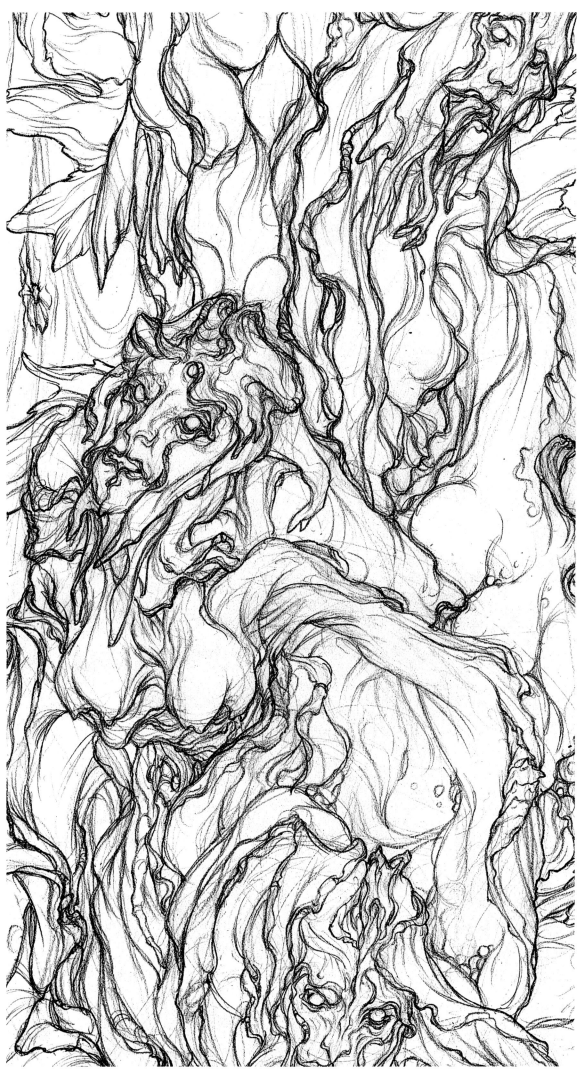

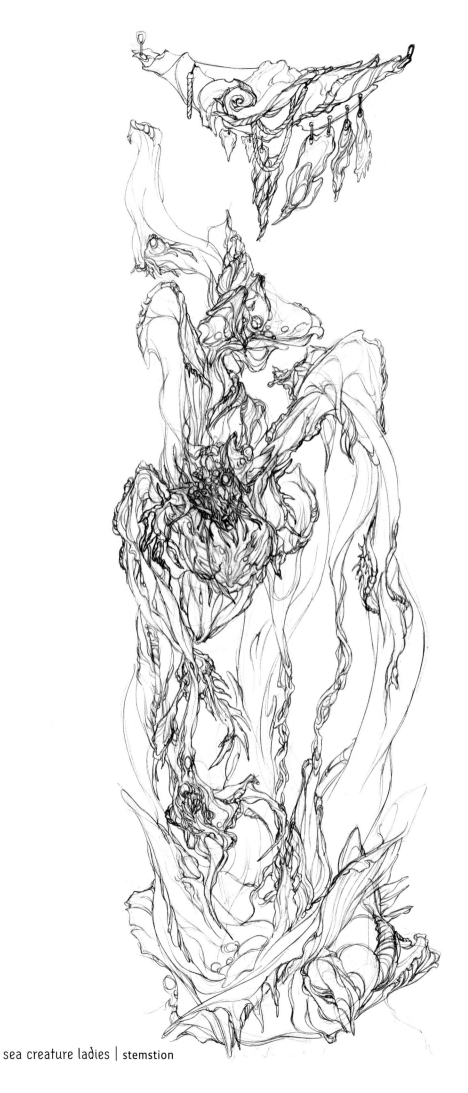

sea creature ladies | stemstion

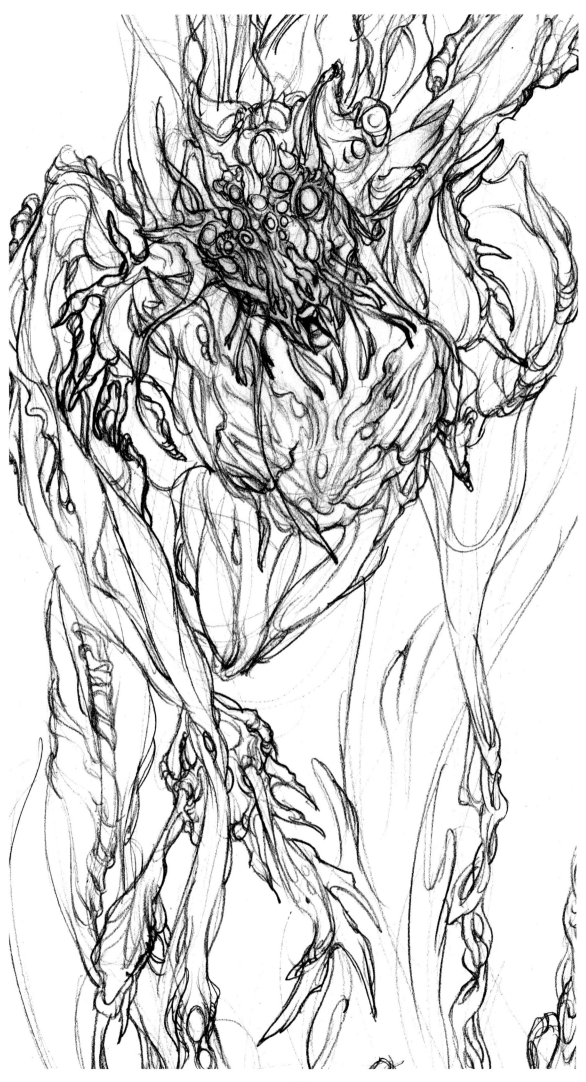

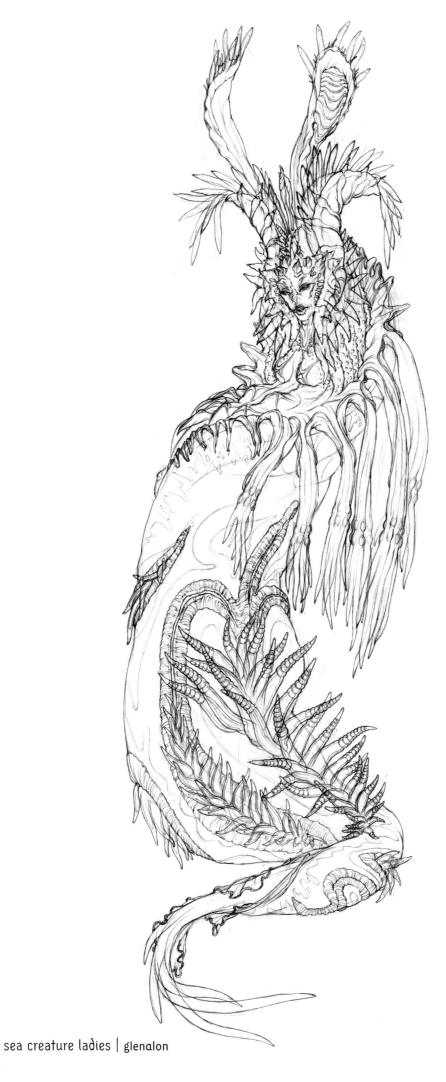

sea creature ladies | glenalon

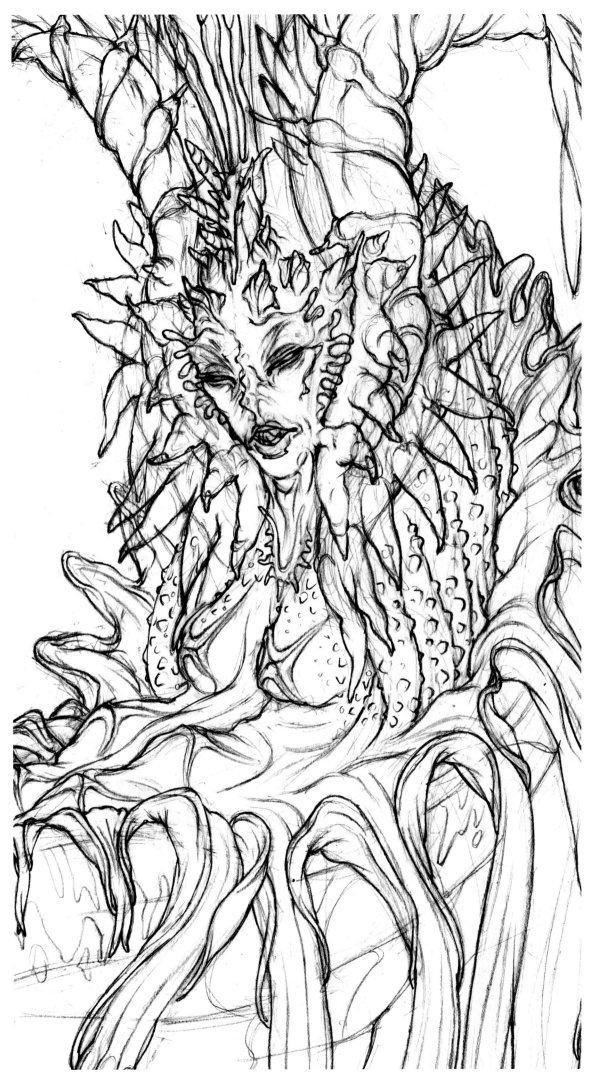

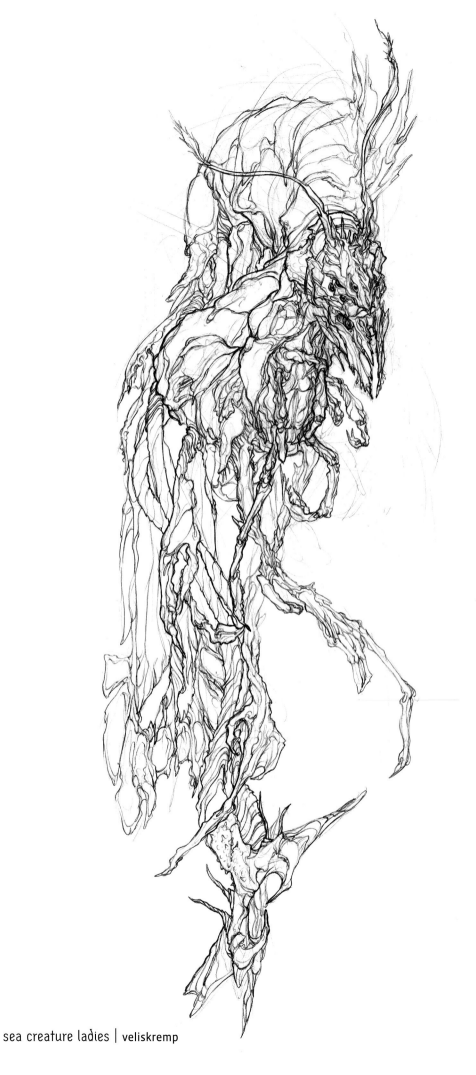

sea creature ladies | veliskremp

5 SIDESHOW STRANGE

Sideshow Strange is an action figures line I created while in school. Included here is the main character, Klyde E. Scarff, and Xylion, and their design variations!

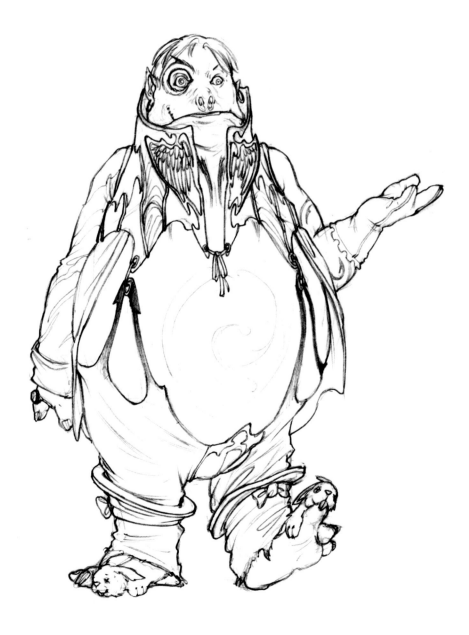

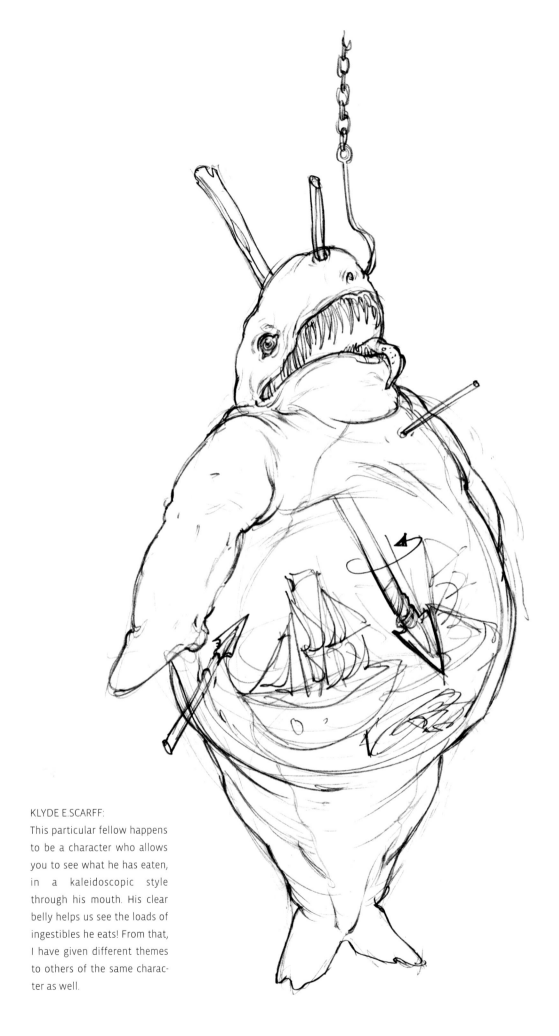

KLYDE E.SCARFF:
This particular fellow happens to be a character who allows you to see what he has eaten, in a kaleidoscopic style through his mouth. His clear belly helps us see the loads of ingestibles he eats! From that, I have given different themes to others of the same character as well.

klyde e. scarff | whale with stirred up shipwrecks inside

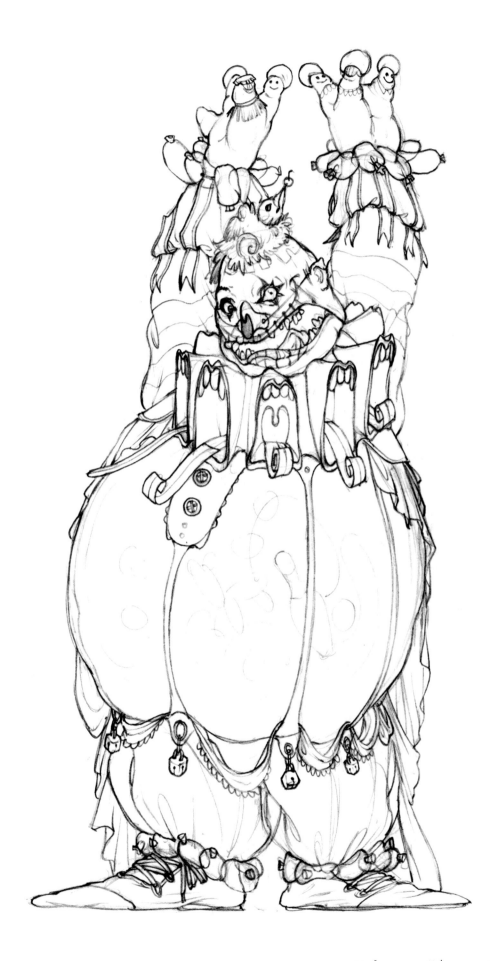

klyde e. scarff | carnival clown

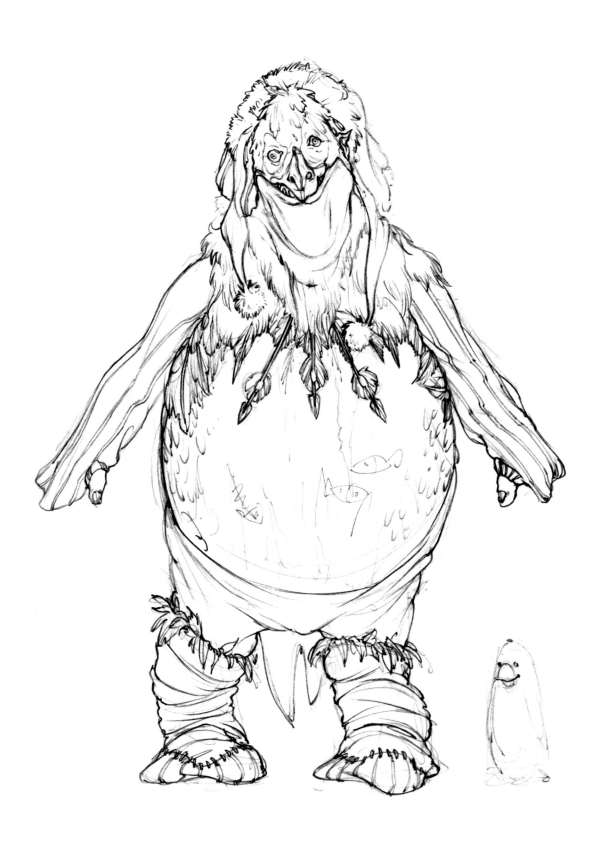

klyðe e. scarff | penguinman with snowball stomach

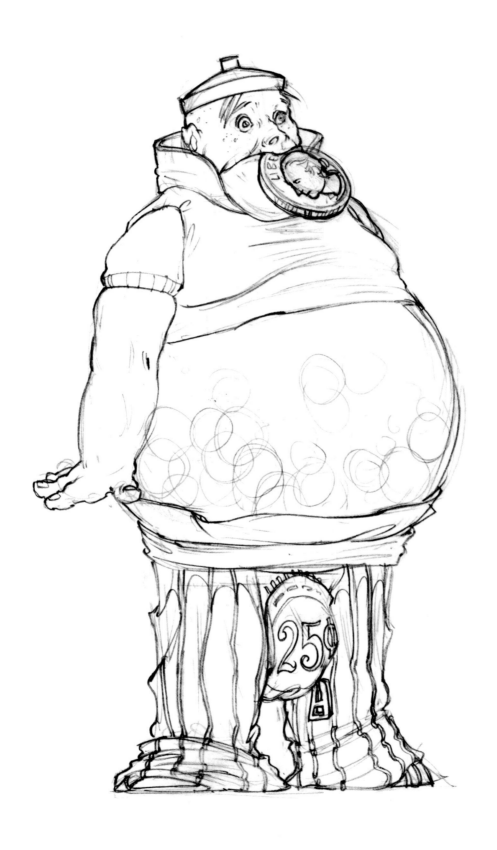

klyde e. scarff | gumball machine: pry open with quarter only

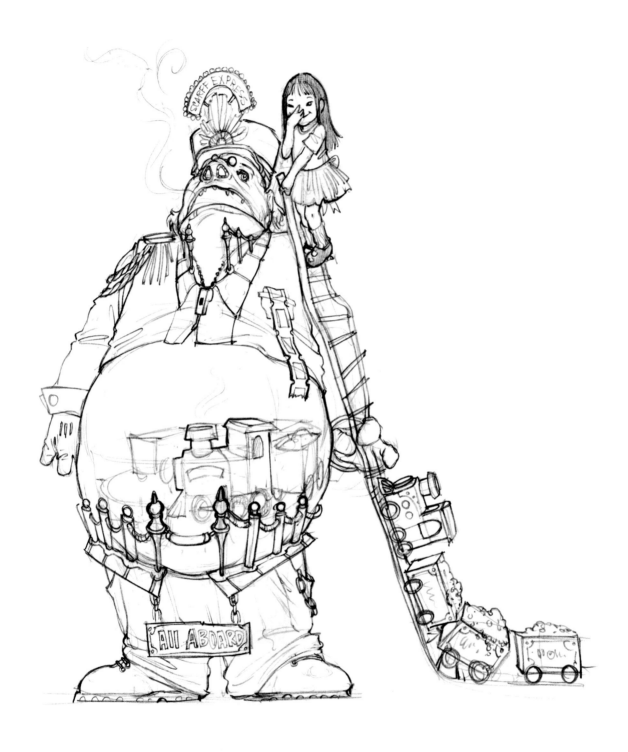

Light shines through his nostrils.
Smoke comes out of his mouth.

klyđe e. scarff | all aboard: scarff express

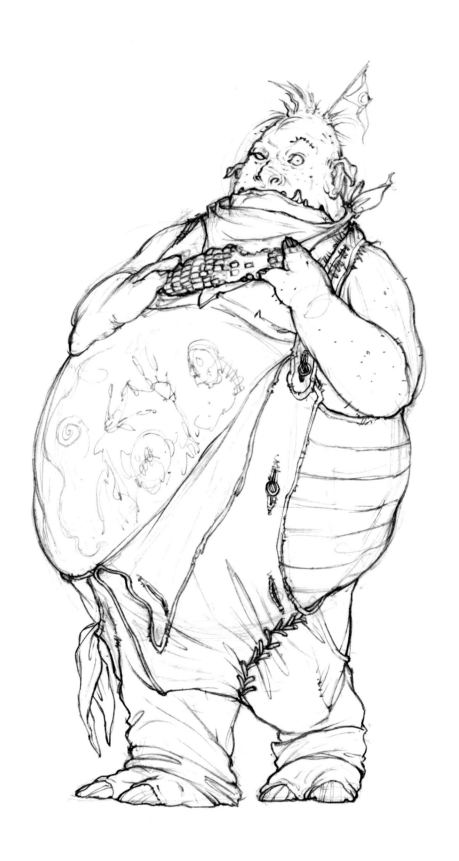

klyde e. scarff | corn niblets & chicken

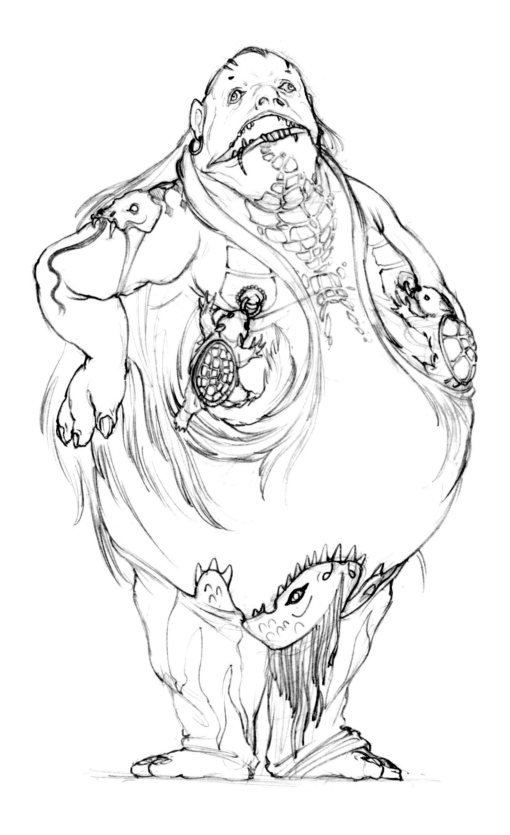

klyde e. scarff

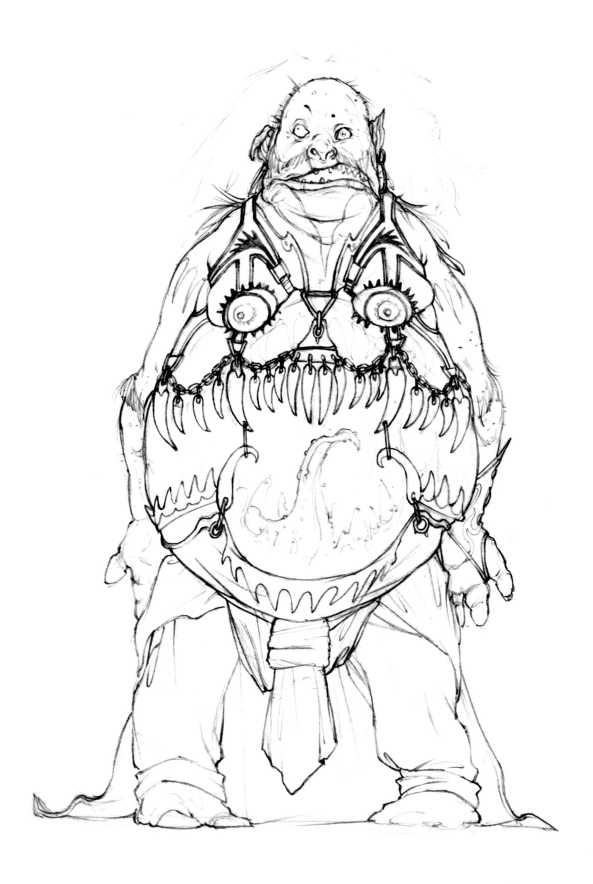

klyde e. scarff

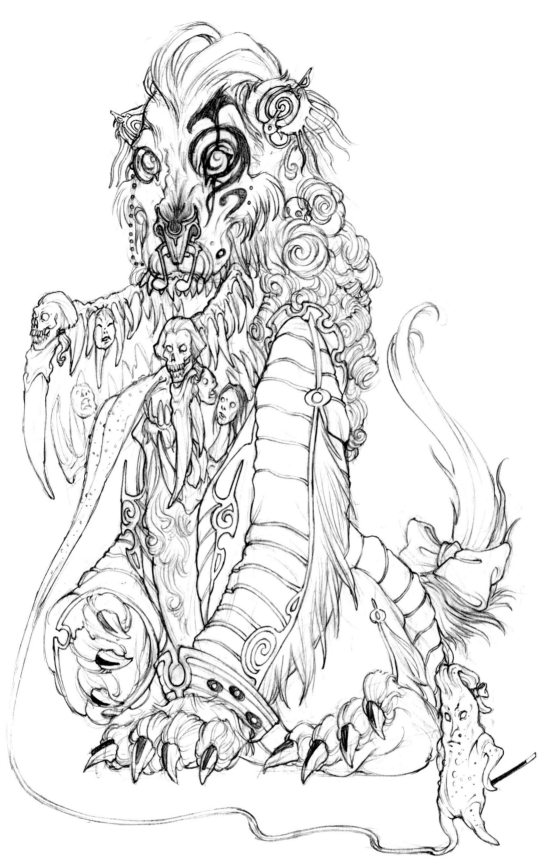

This lion has children stuck between his teeth, and Lixster (his tongue) plays musical notes with them! What else would you do if you lived in a secret jungle with no access to dental floss?

xylion

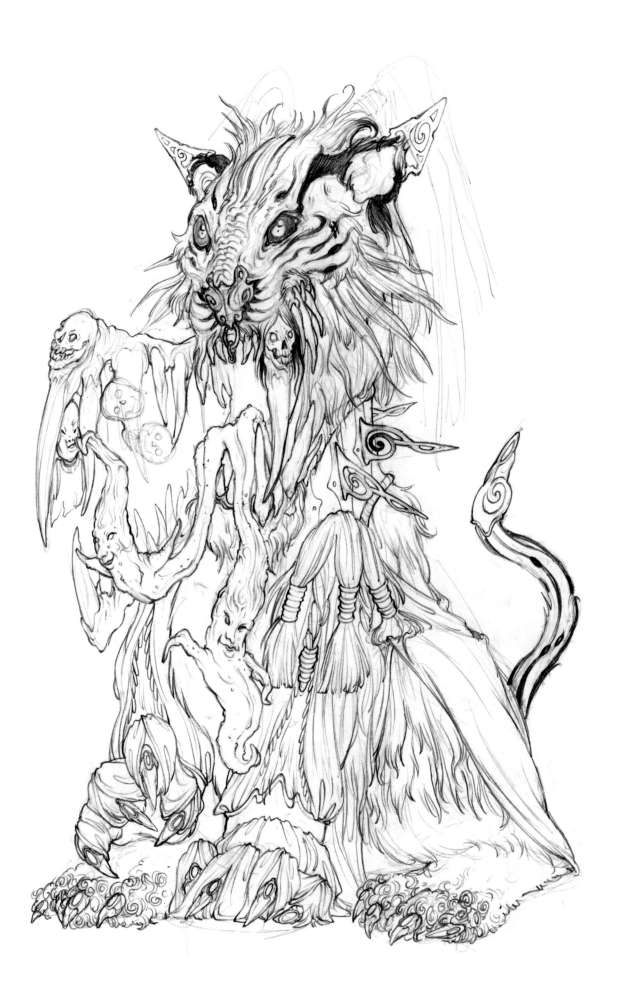

xylion

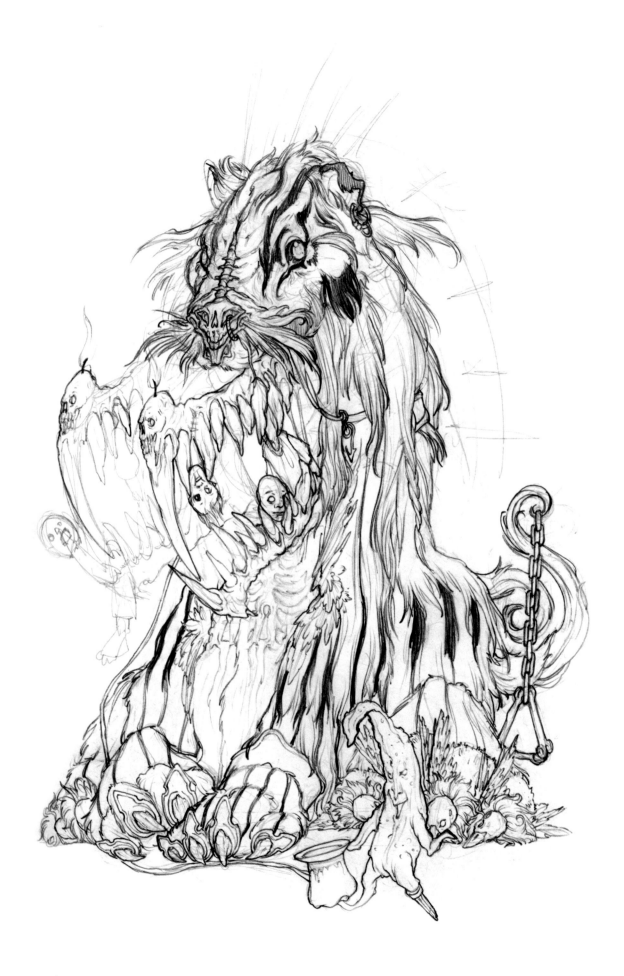

xylion

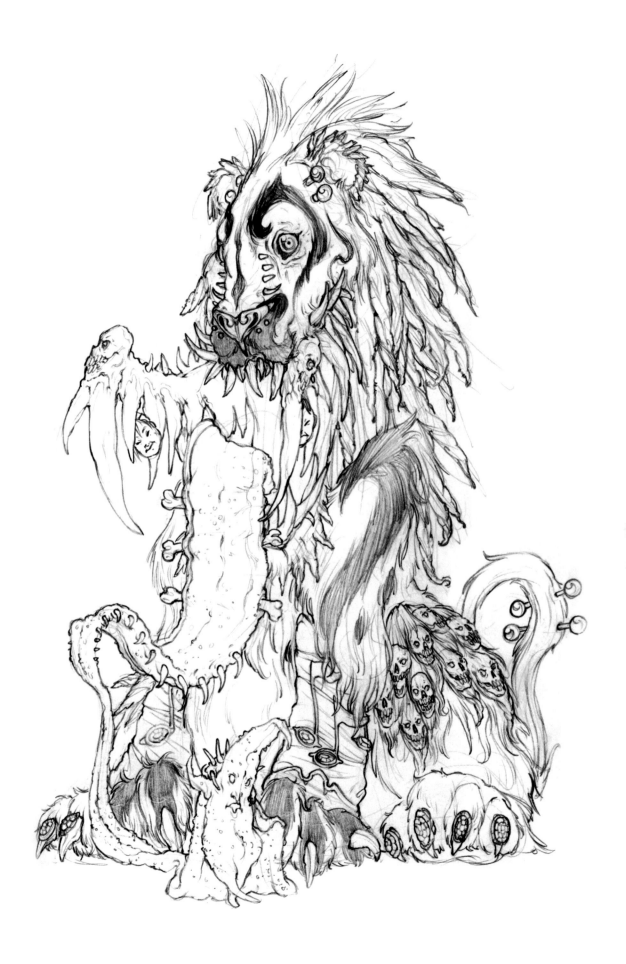

xylion

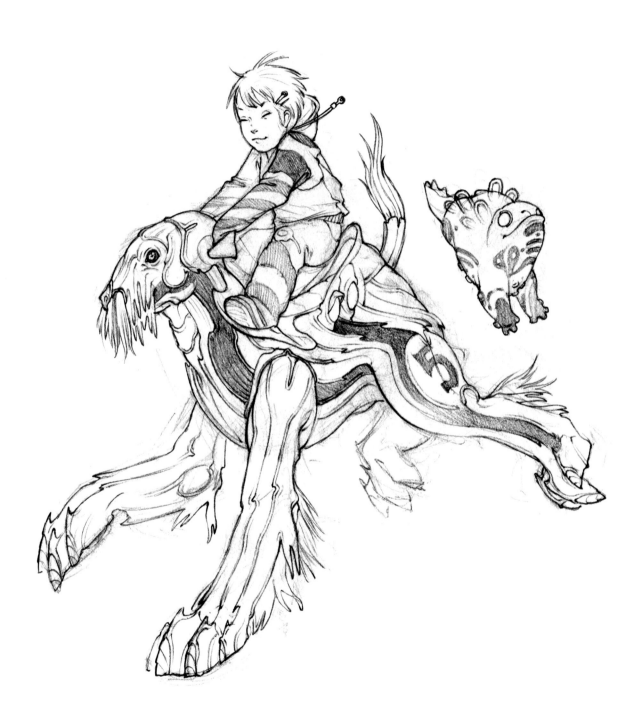

6 RACING BOY

This is one character of a racing game idea I had. He's a young lad with a bio-mechanically engineered, canine-shaped racing animal. You can inject different colors and designs into its skin, and you can change its size (Think of blowing up shoes with air pumps! Well, if your shoes were inflatable, that is!).

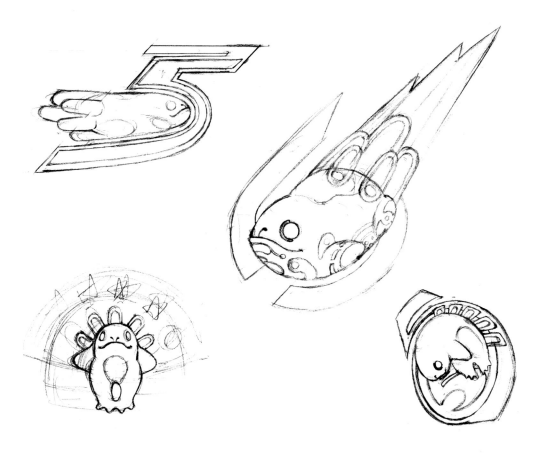

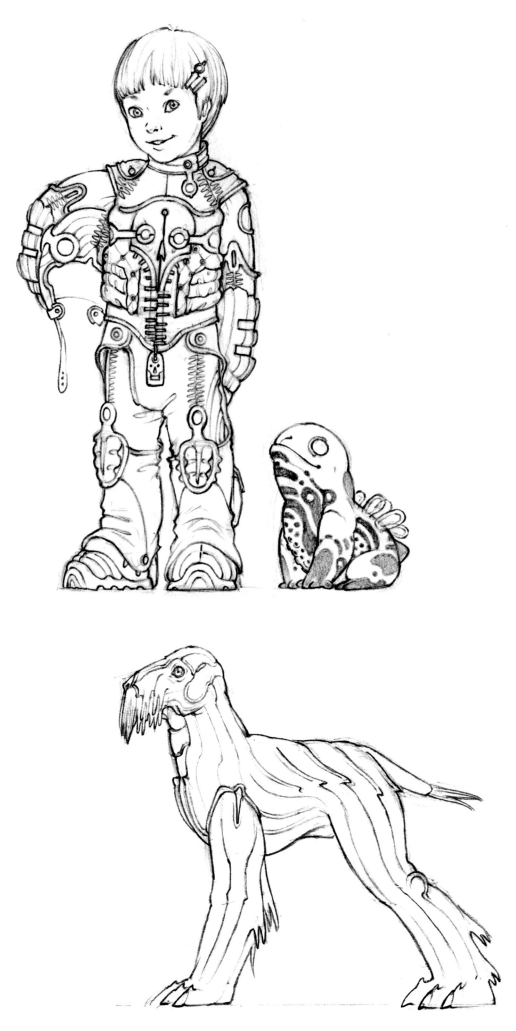

racing boy | racing boy & racing terrier

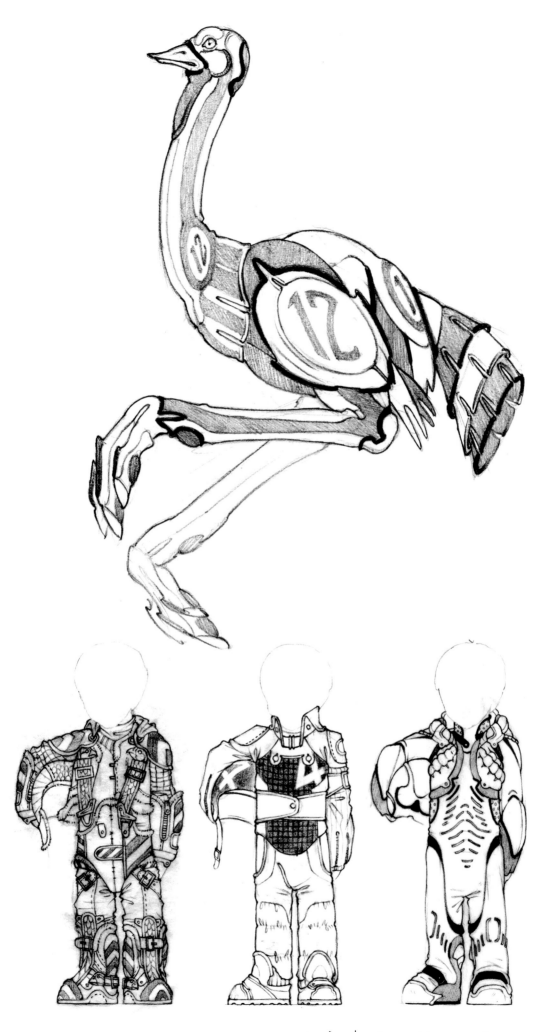

racing boy | racing ostrich & racing boy costumes

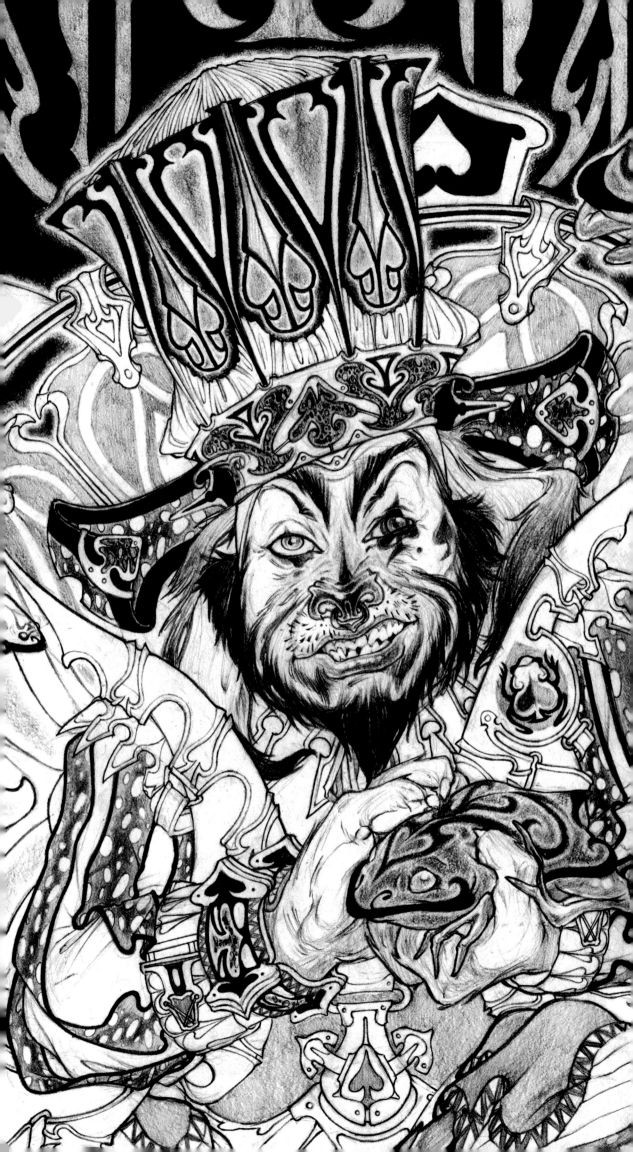

7 ROYAL DECK

The "Royal Deck" series, which is what this was first called, eventually evolved into different thrones inhabited by characters representing Spade, Club, Diamond, and Heart. The characters were drawn seated on their thrones, symbolizing their royal-ness and how they are the main representative of their symbol. I first did them as one card each... or one throne each, but I didn't want to let the characters just sit there, so now they have thrones with activities, or thrones they just happen to be at whilst enjoying a favorite hobby or pastime of their choosing.

I haven't named them yet, for I feel like I'll discover more about them as I place them in different scenes and add more things to their life and activities. These drawings are evolving as I draw, and although there is a main idea I stick with in the beginning, even I cannot tell where they will end up!

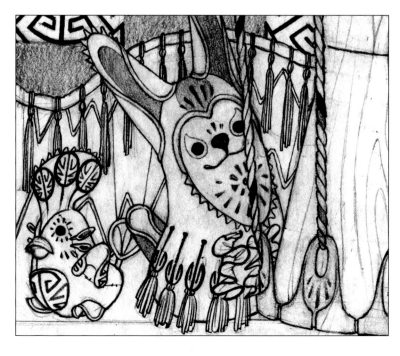

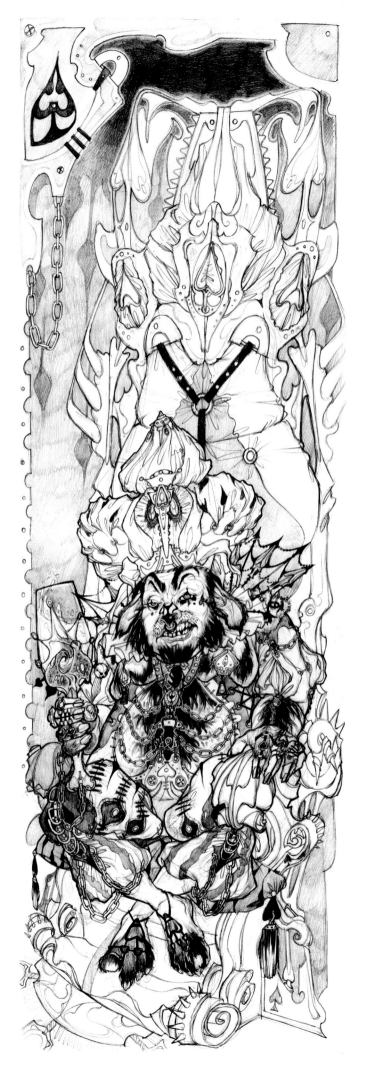

The first drawing I did for this series was of the Spade character. I drew him relaxing with a glass of wine in hand. I thought how that wasn't very fancy of him, to just sit on his throne while having to deal with others, but at the same time, what would he be doing? It would be boring to just sit there all day, so if they were going to just sit, why not have an activity for them? I am basing this conclusion on seeing how these royalty-types have to meet and greet people while sitting in one spot all day, so I might as well give them something to do.

It's also kind of like everyday-life, we are all stuck somewhere, in a job or something we are obligated to do. Hopefully we can make it more fun than it is, or at least do something about it to make it more bearable.

royal deck: spade | spadasplendore

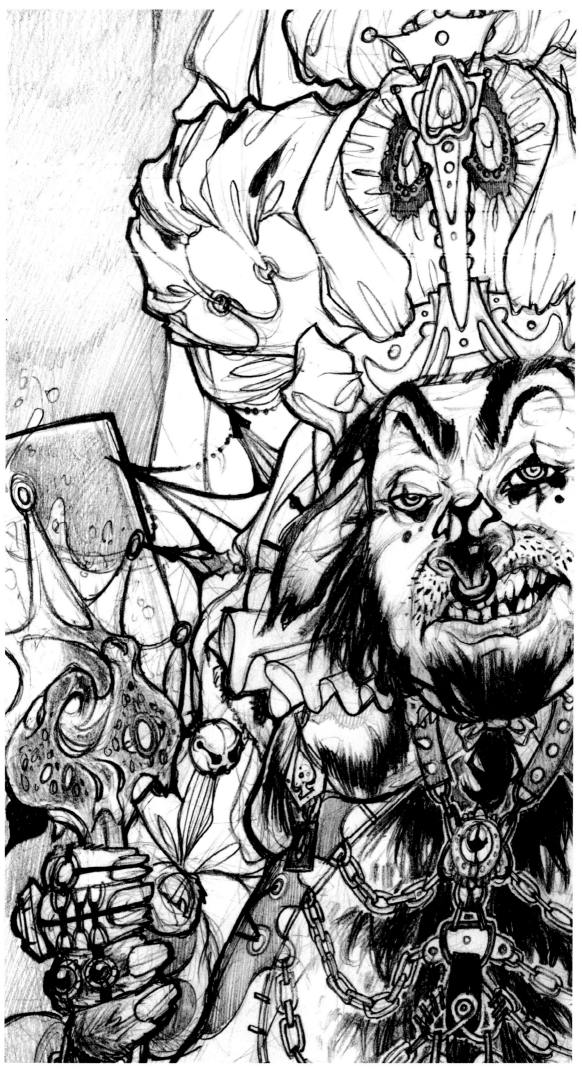

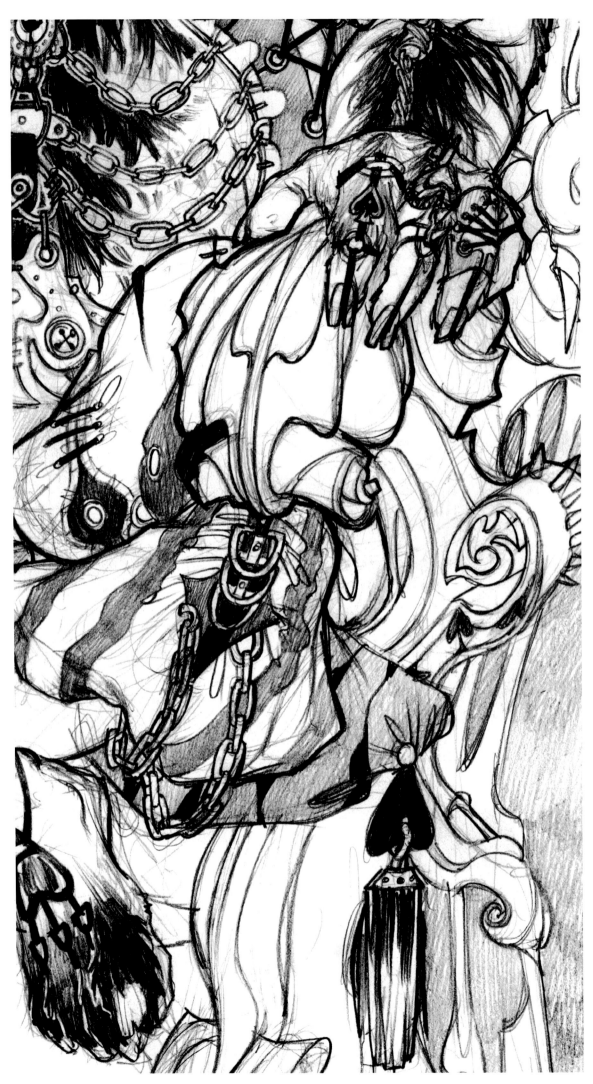

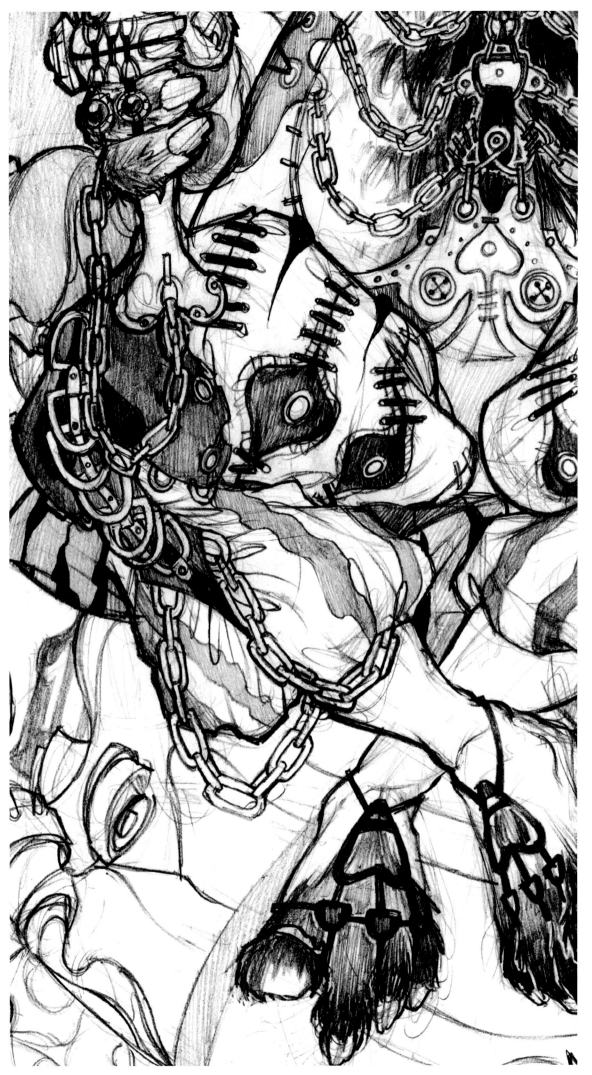

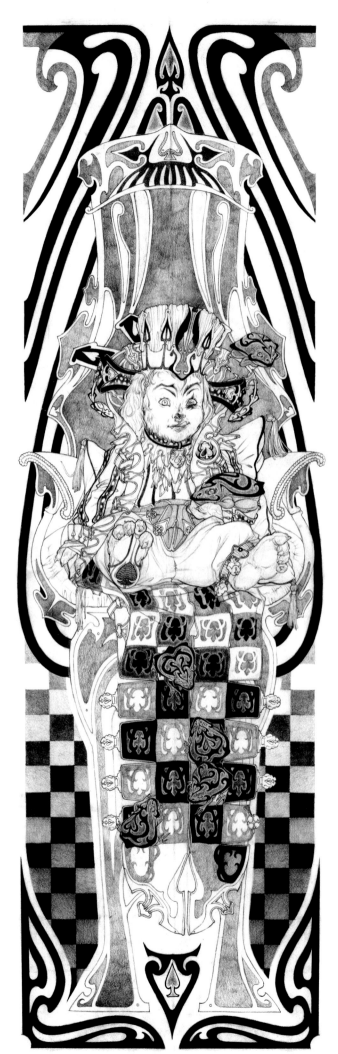

This scene has a younger Spade character in one of his favorite articles of clothing: which has a checkers-like game played with toads resembling the spade symbol on his jacket coattails. One day whilst doodling some graphics, I came up with something that looked like I could use as the spade symbol, and from that I thought up the game.

royal deck: spade | weespadacotta

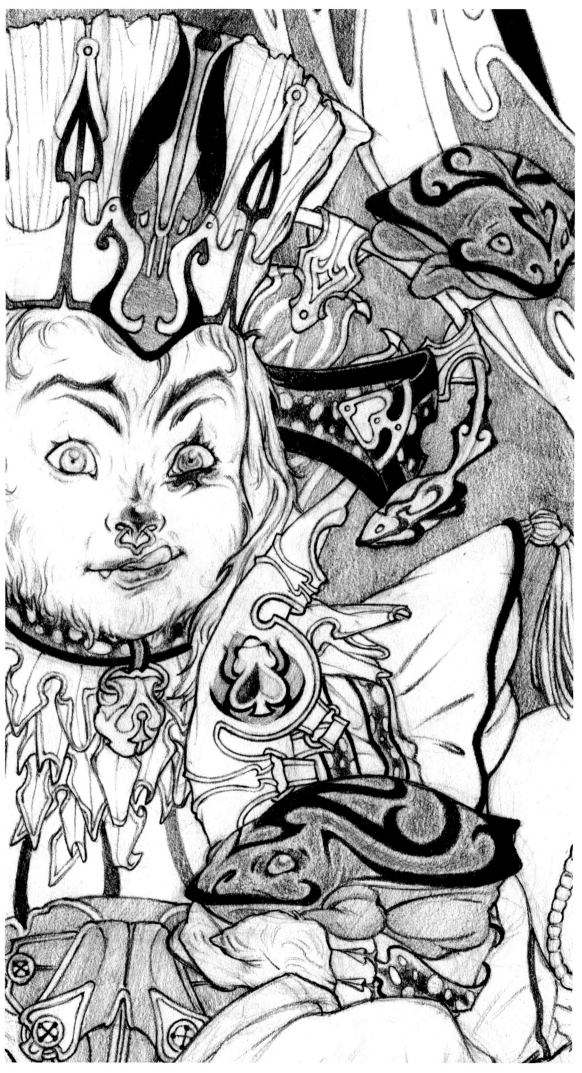

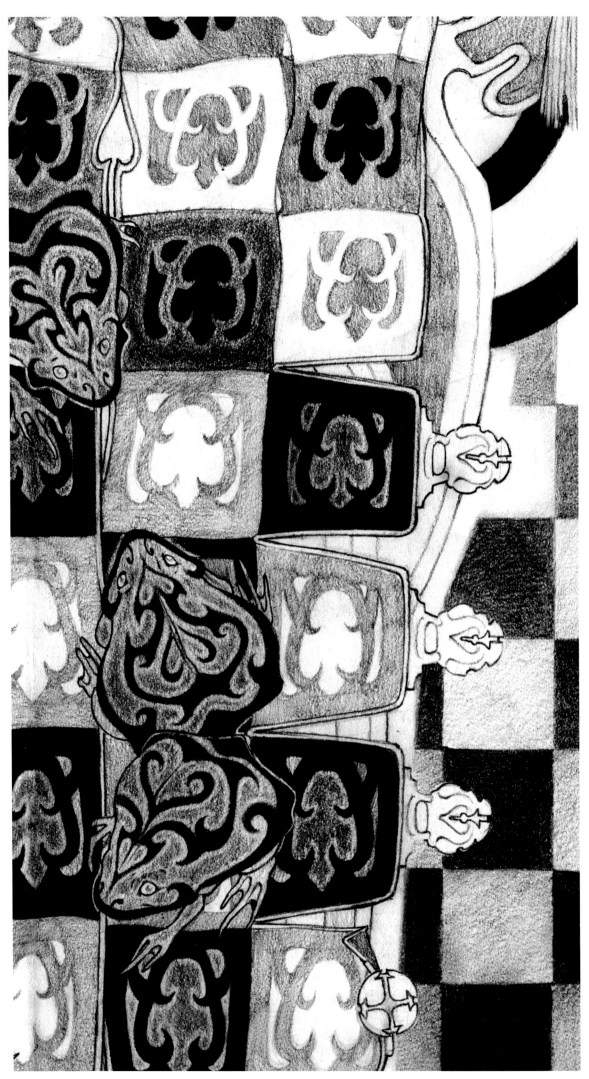

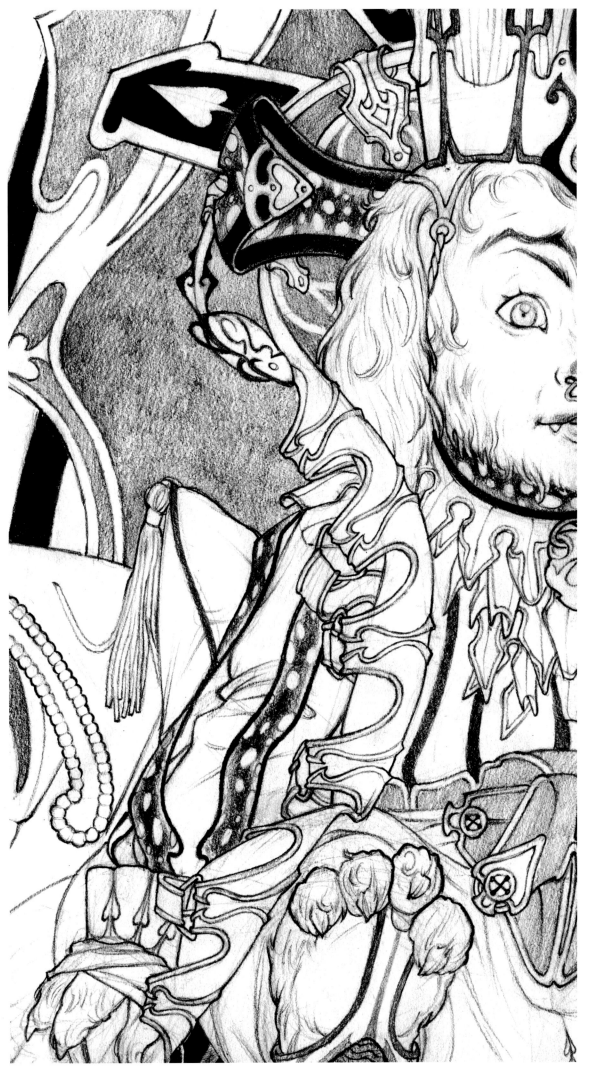

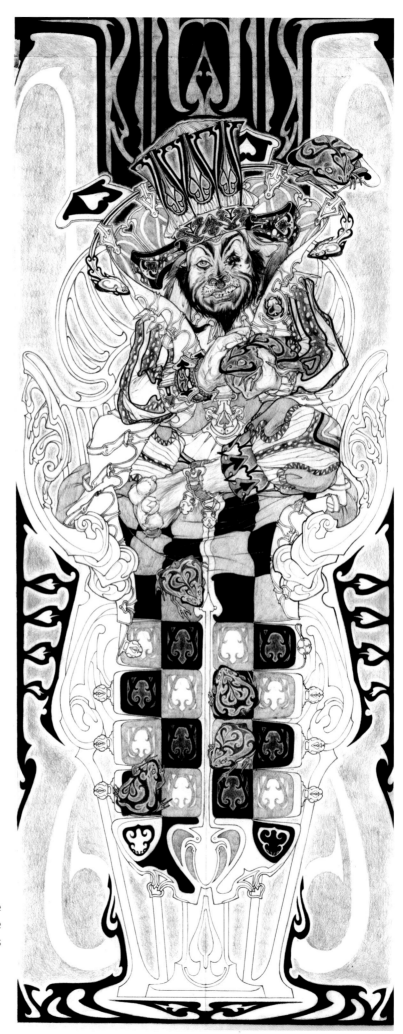

Here is the older Spade character playing the same Spade coattail game as when he was younger.

royal deck: spade | spadacotta

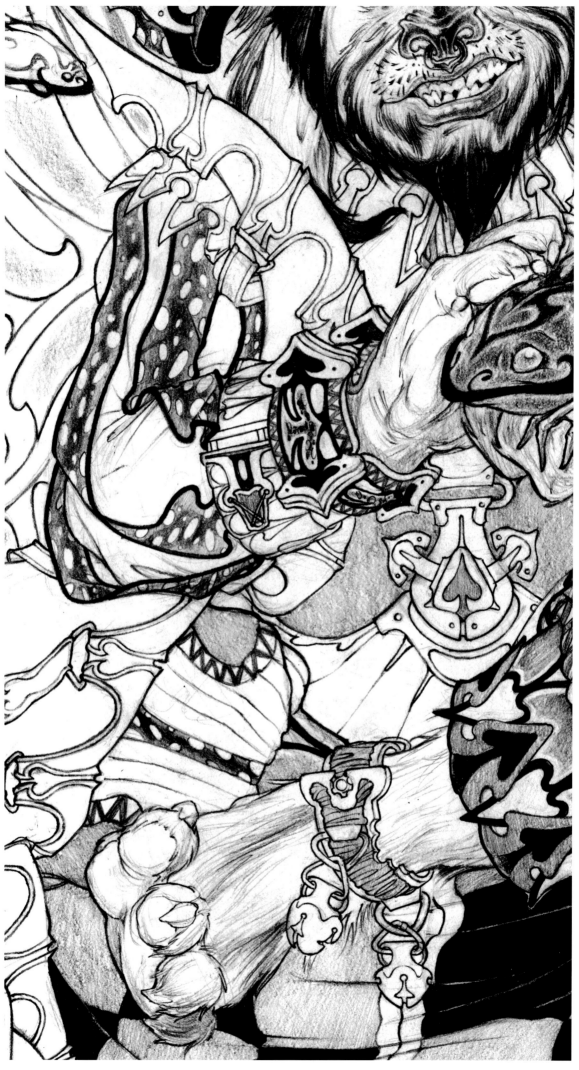

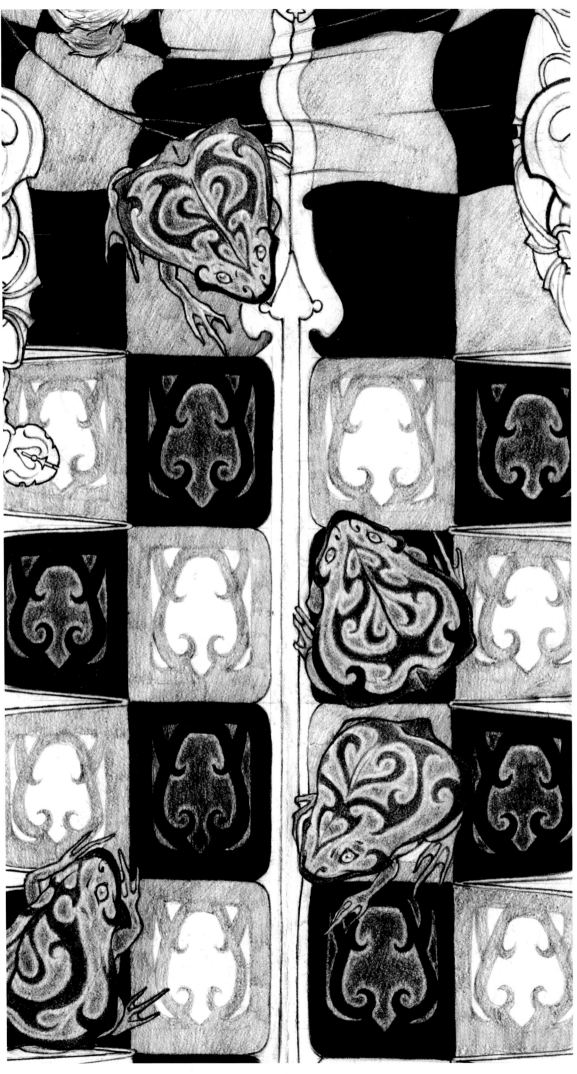

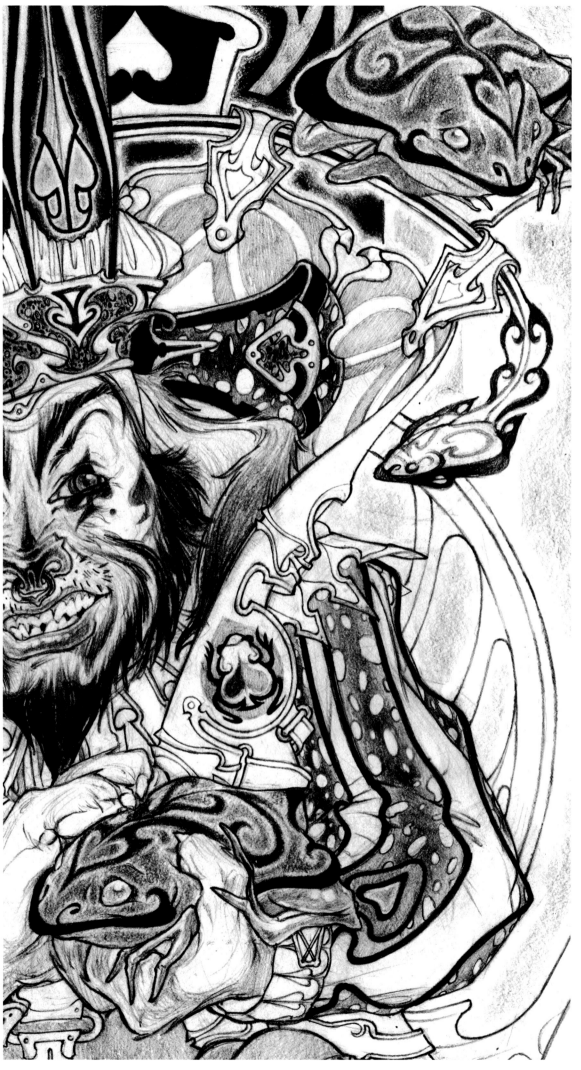

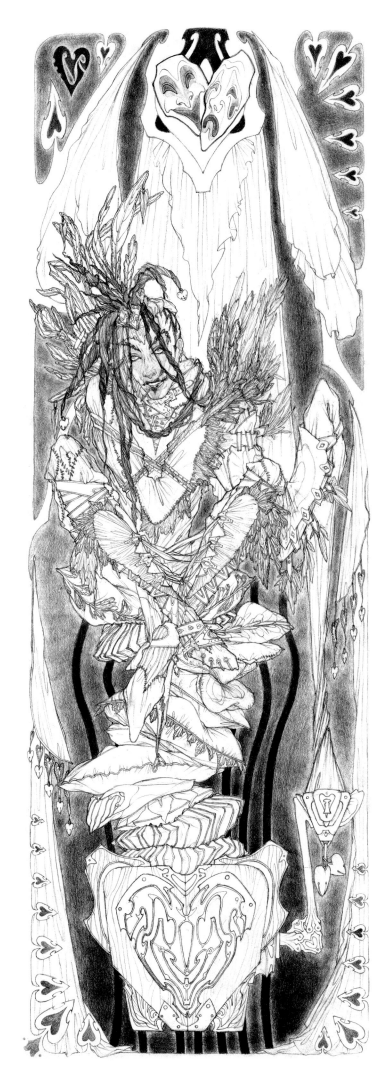

The Jester of Hearts is always in a straight-jacket. He wears a jacket for everything he does, from violin-playing to joke-telling or poetry-reading. Although the straight-jacket's movement is restricting, the Jester has one made up for everything, so it's almost like he's not wearing one.

royal deck: heart | jack n' jest

128

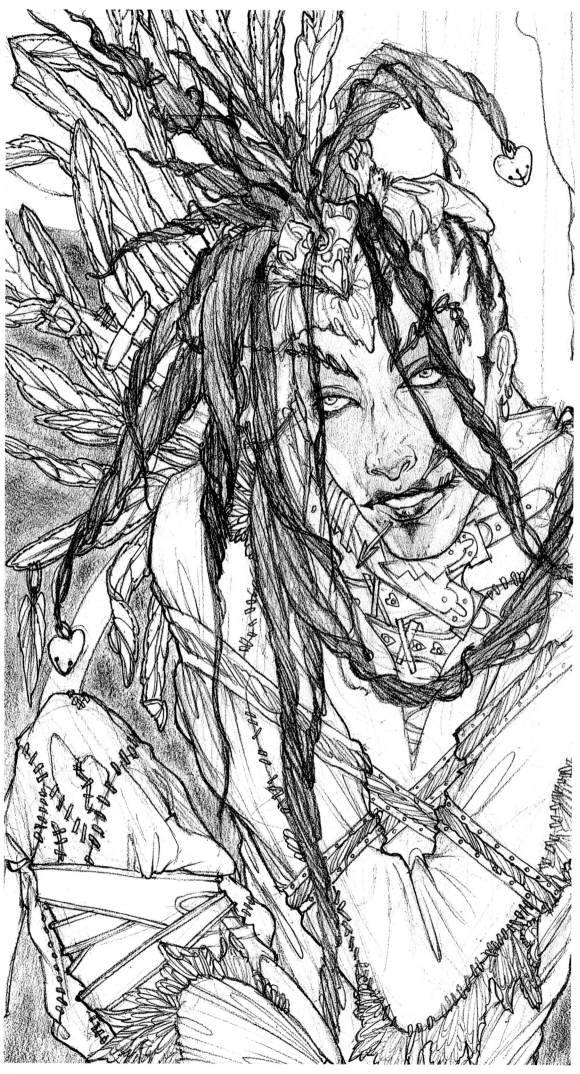

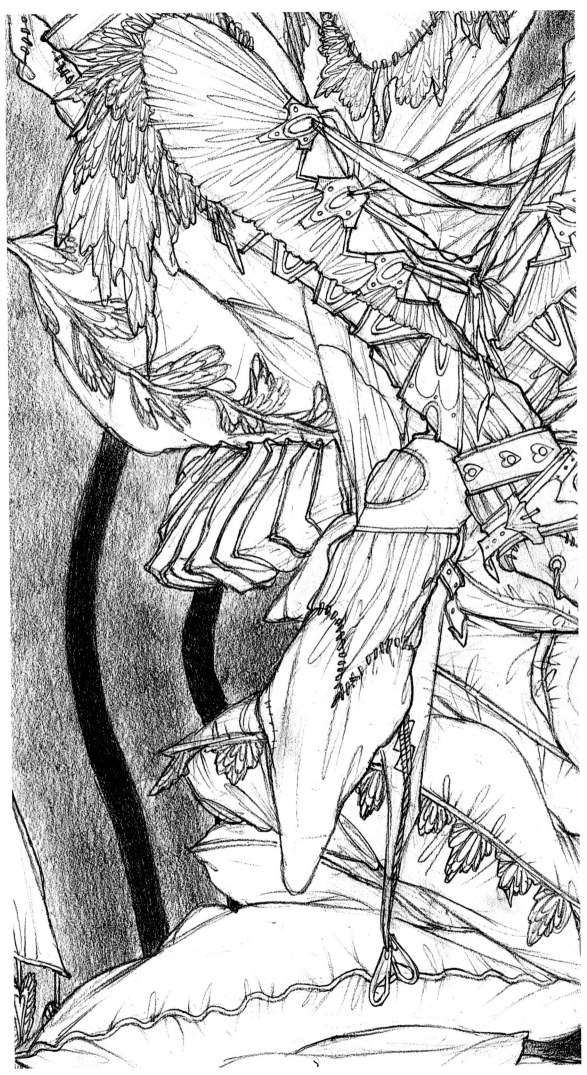

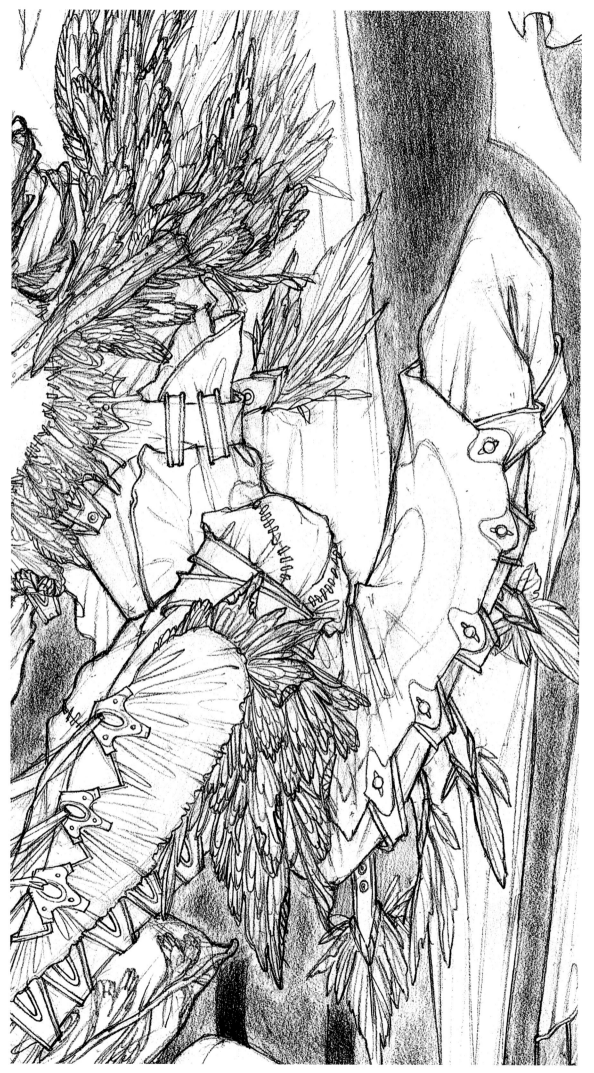

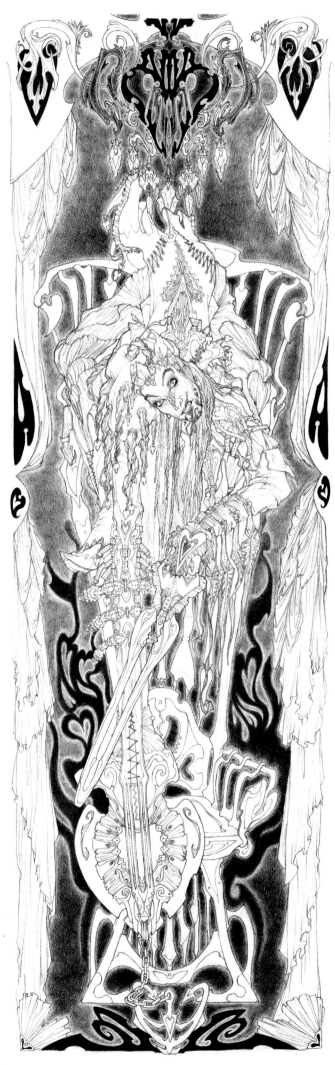

royal deck: heart | strattagiguer

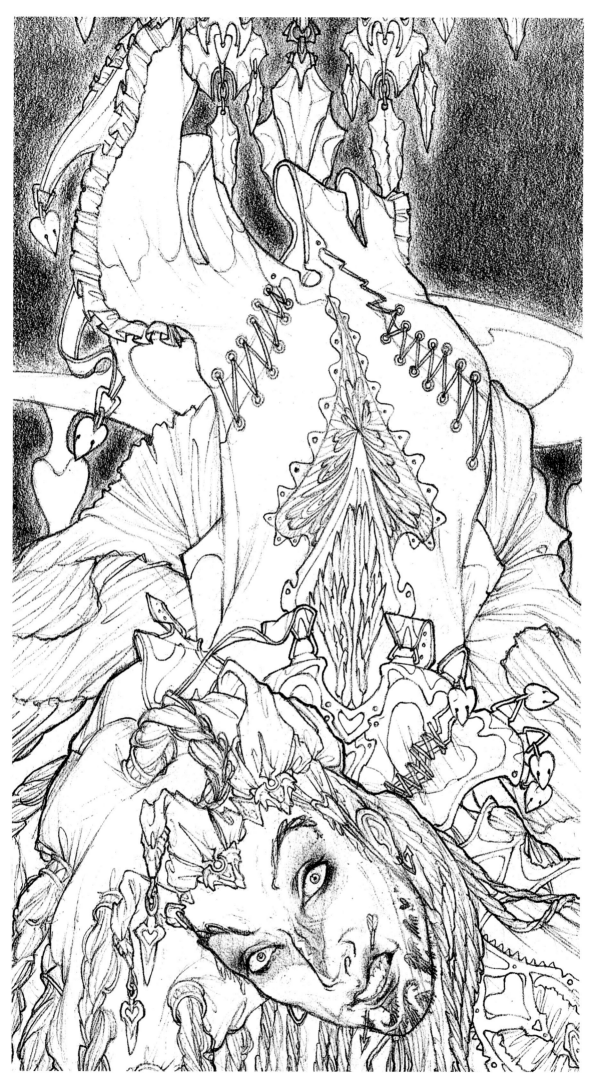

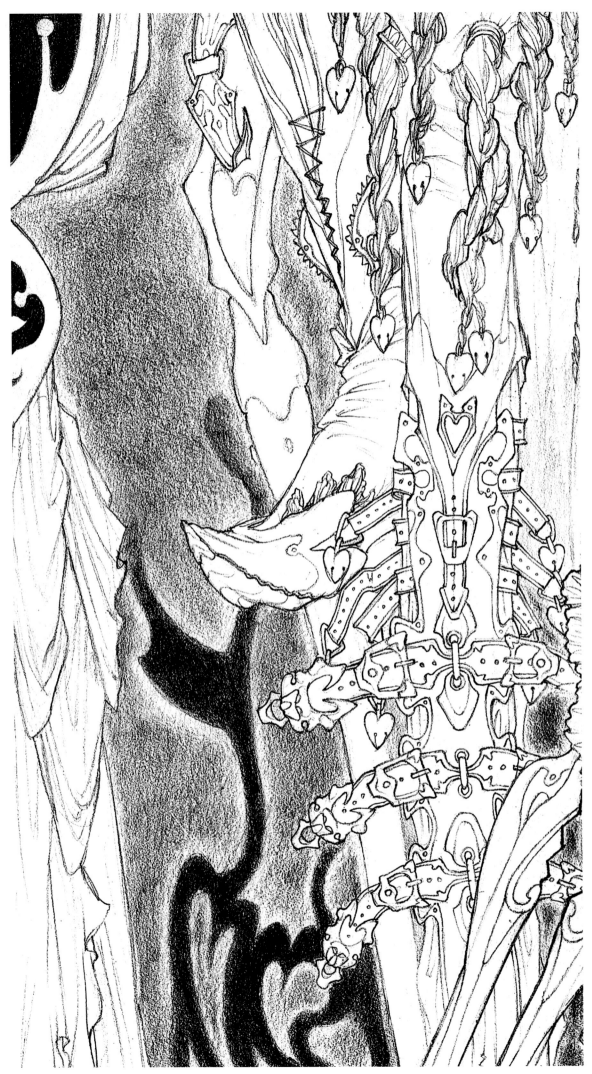

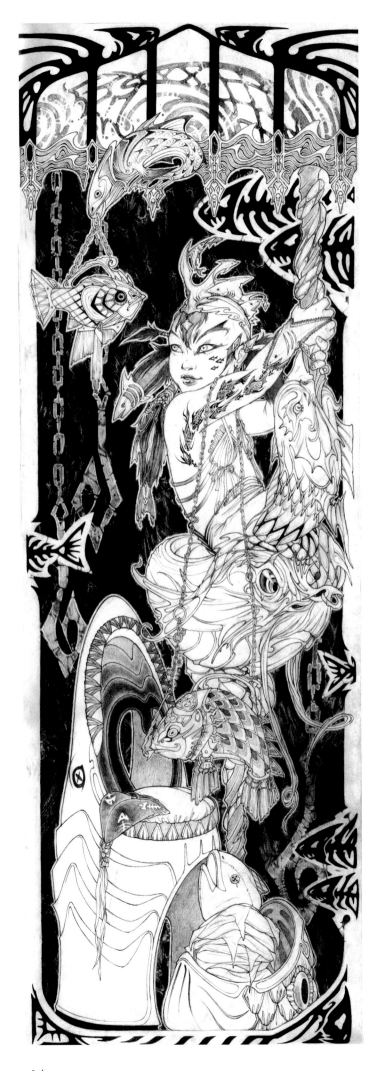

royal deck: diamond | carousail

136

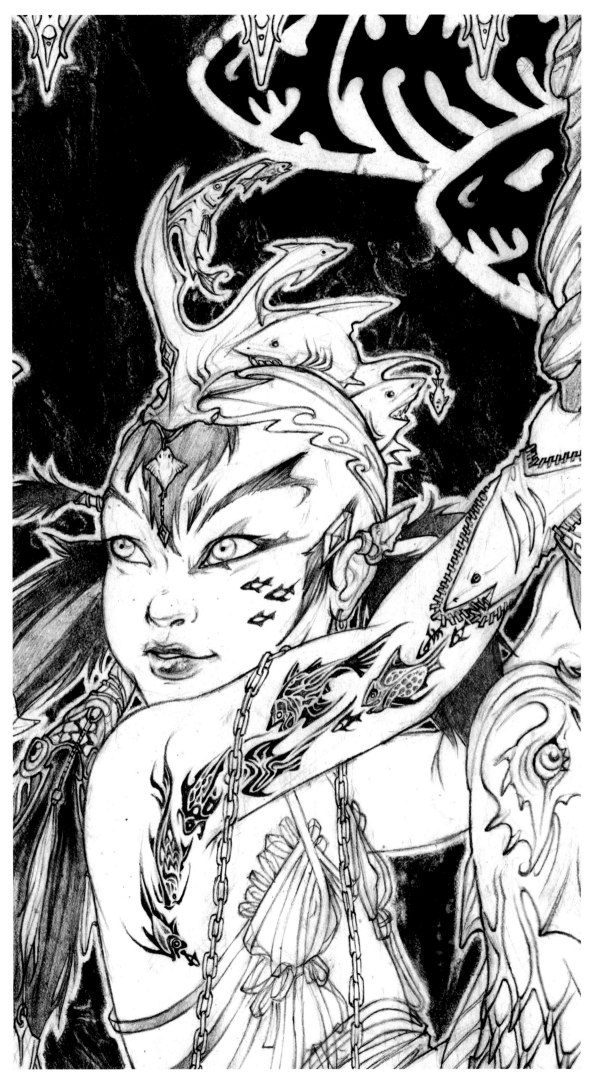

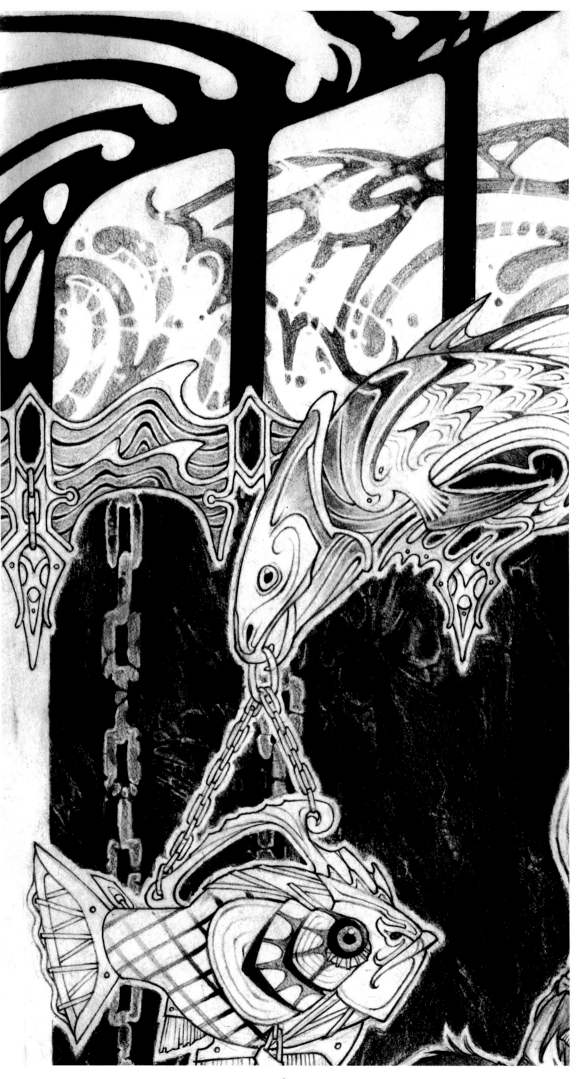

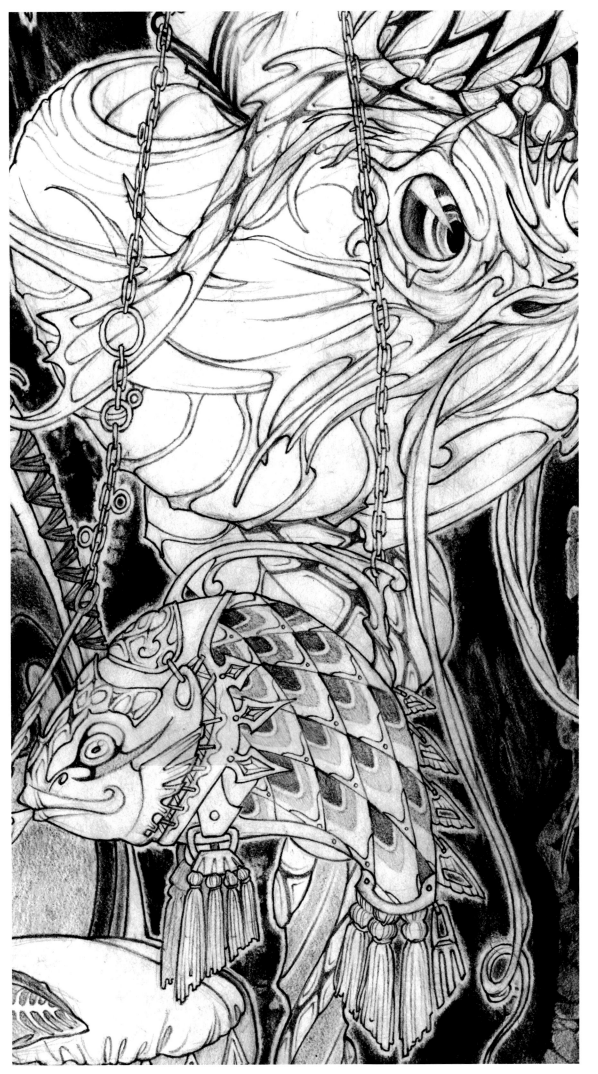

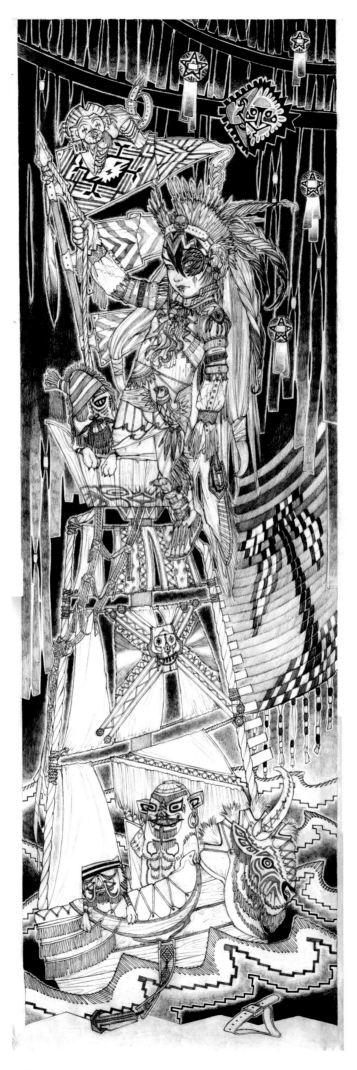

royal deck: diamond | sunny sea leather

140

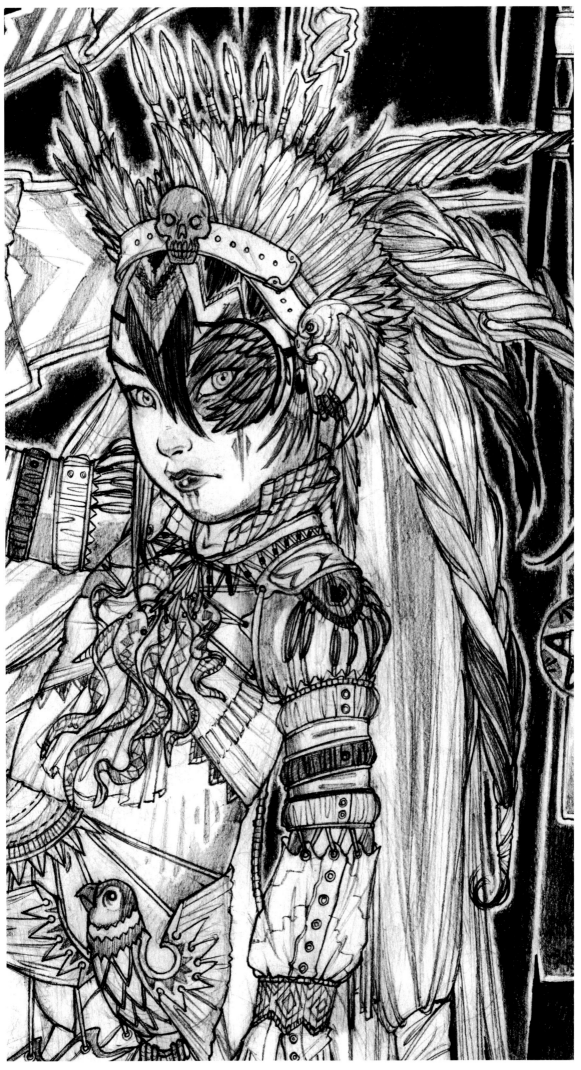

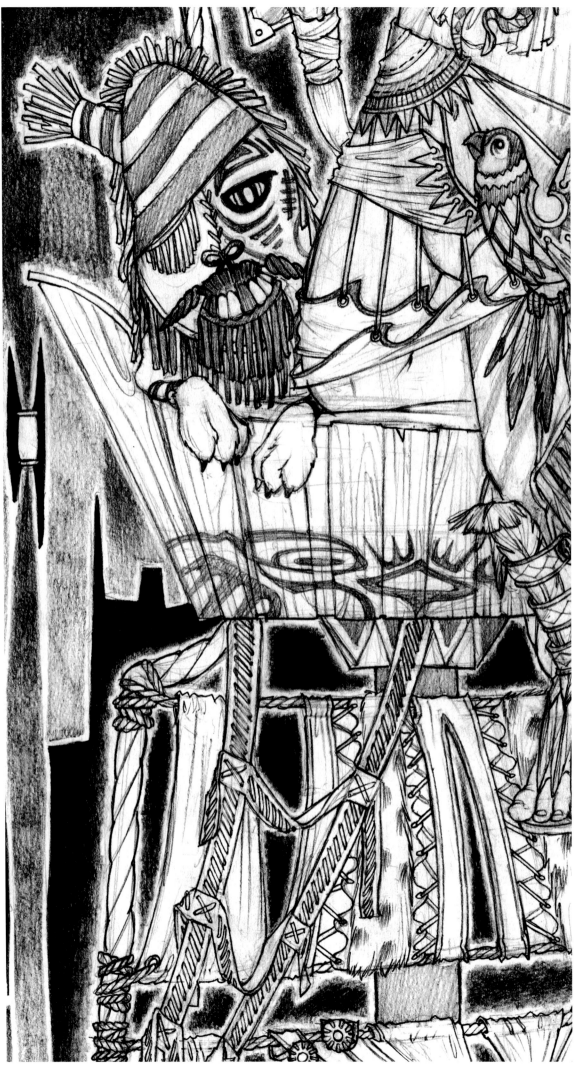

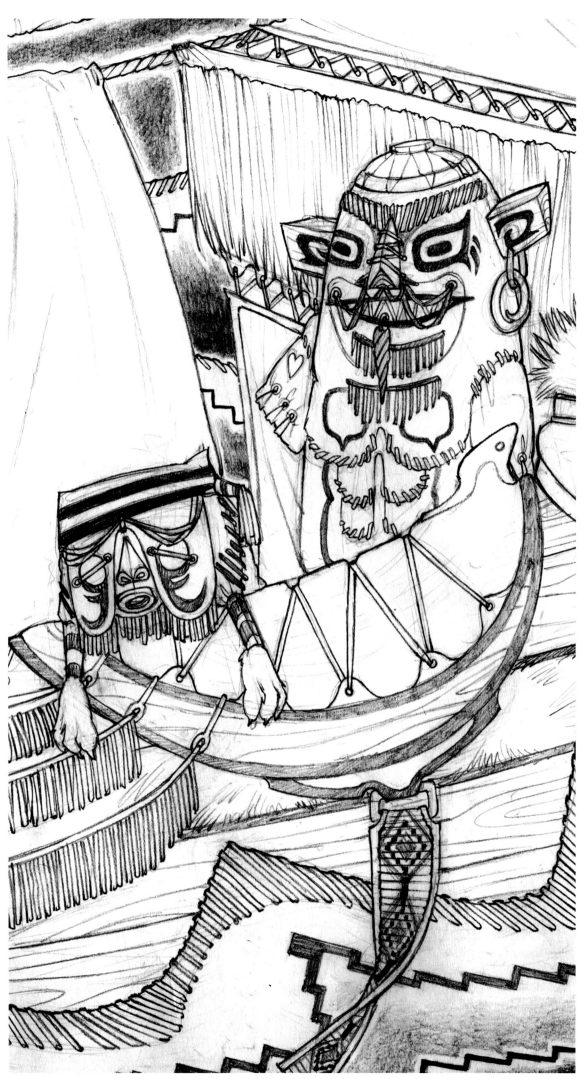

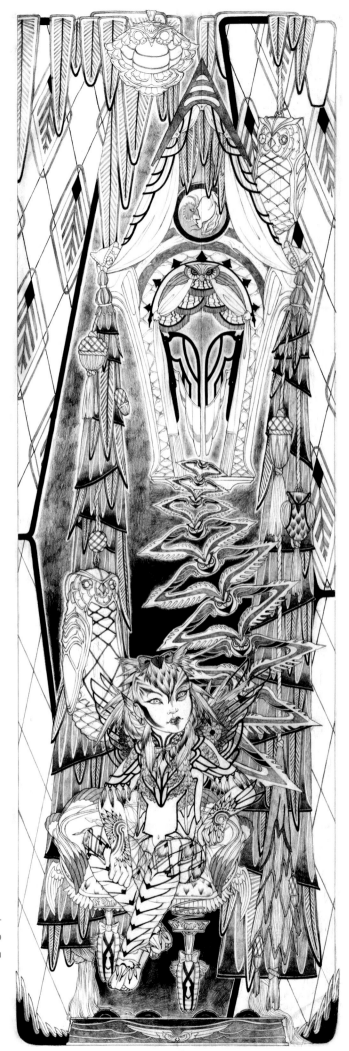

This throne is sort of a cuckoo clock where the cuckoo bird's been replaced with an owl, and set on a stage.

royal deck: diamond | naht foret

144

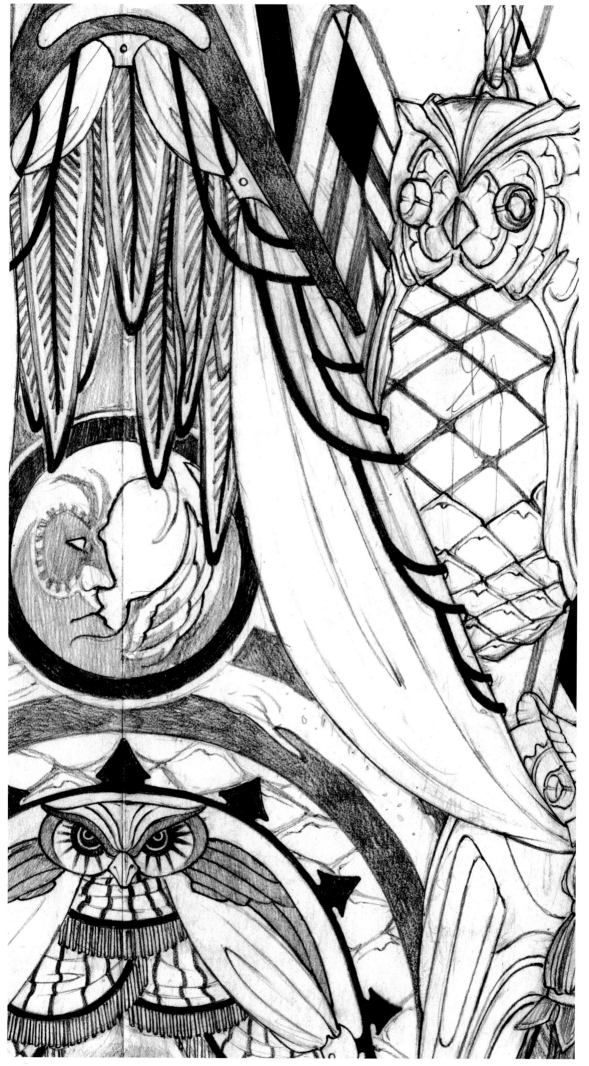

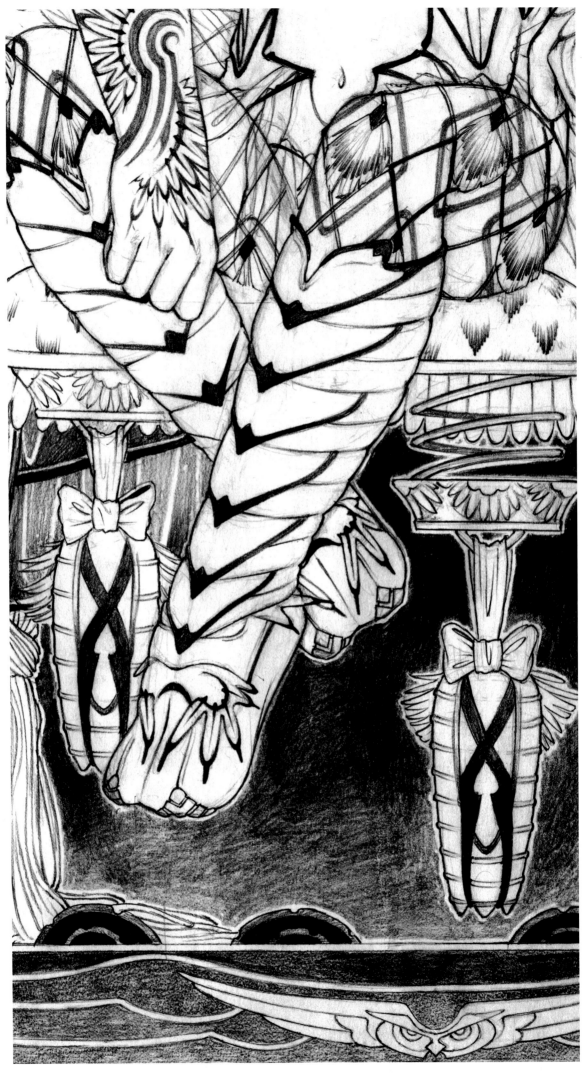

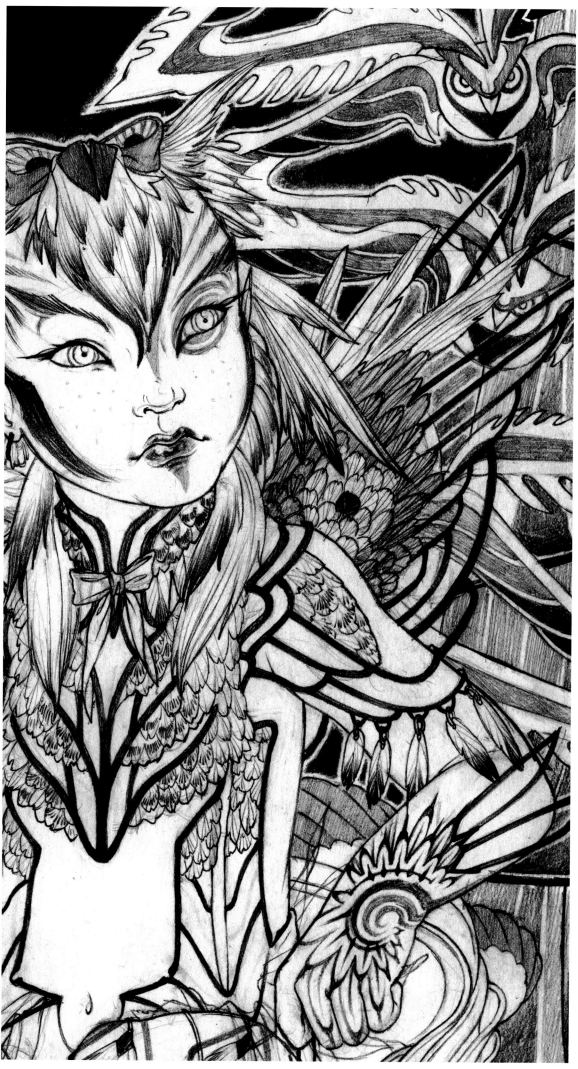

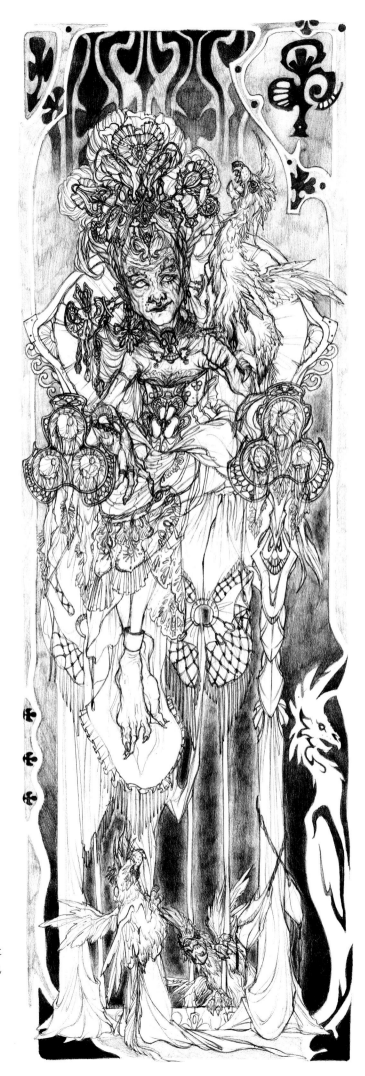

She sits on a throne that
houses the eggs of her pets,
a parrot-feline hybrid.

royal deck: club | squibblesquabble 148

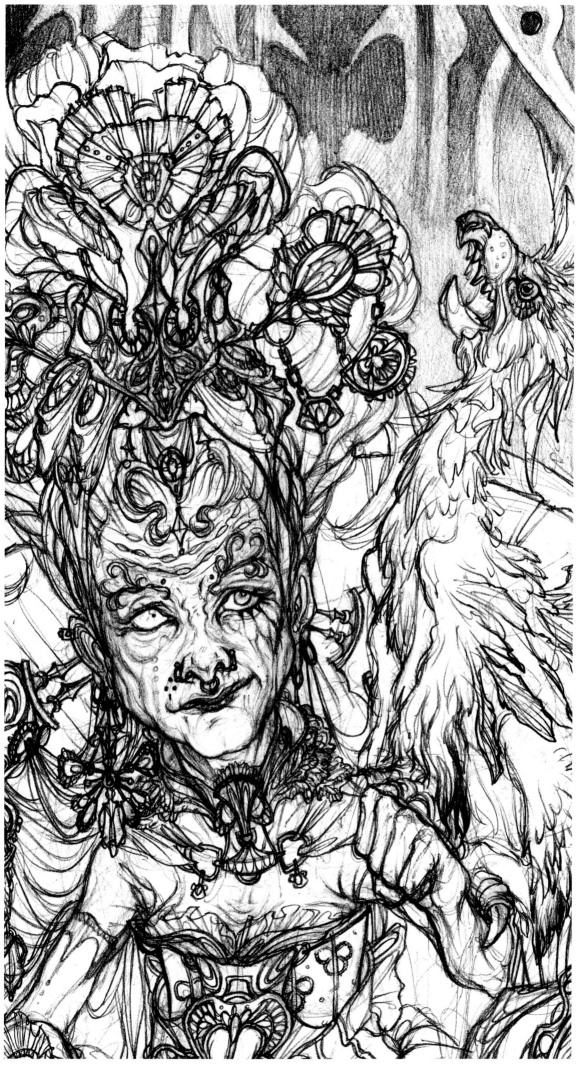

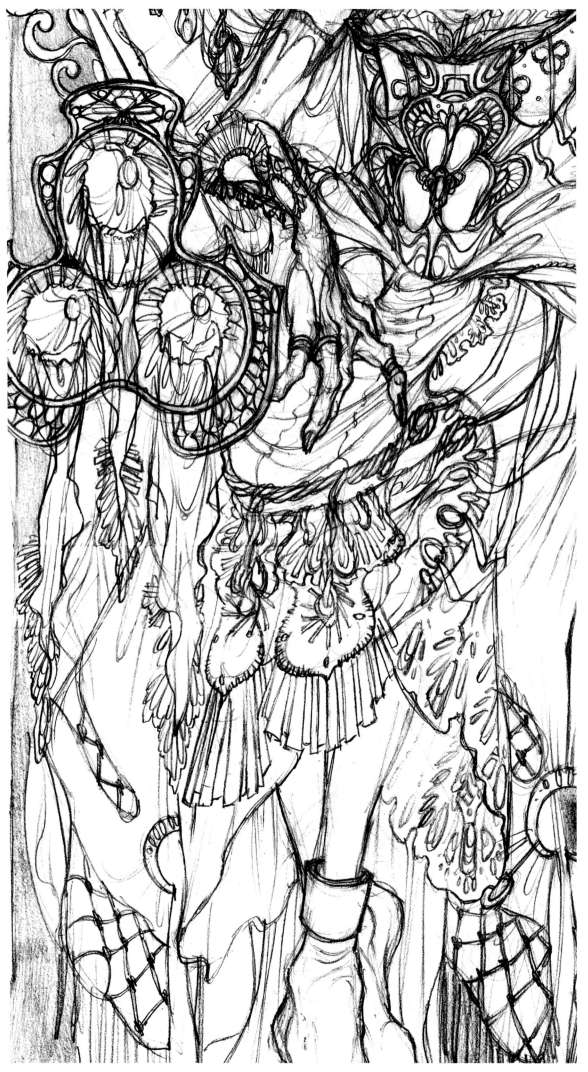

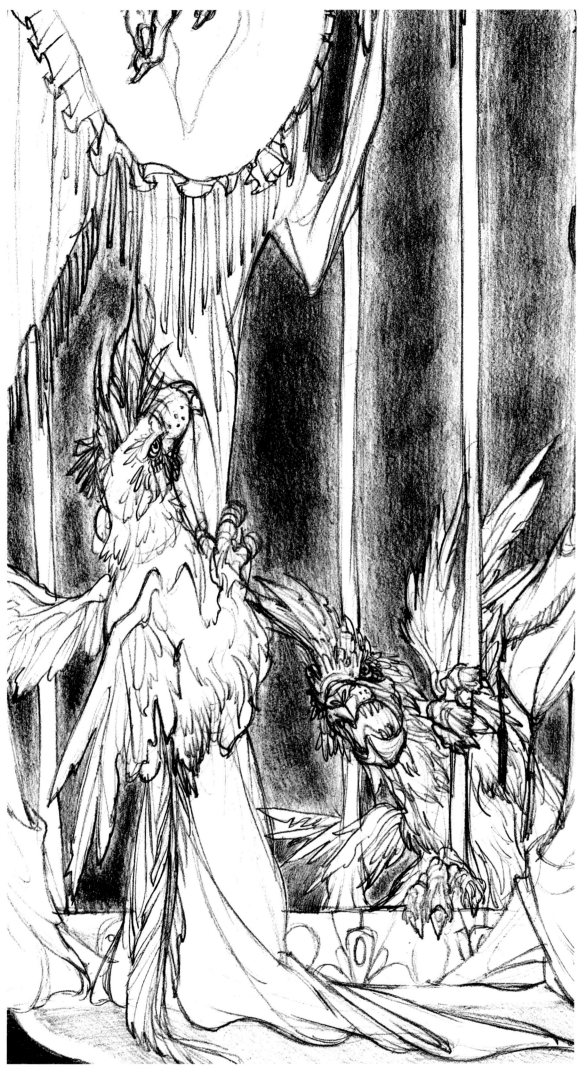

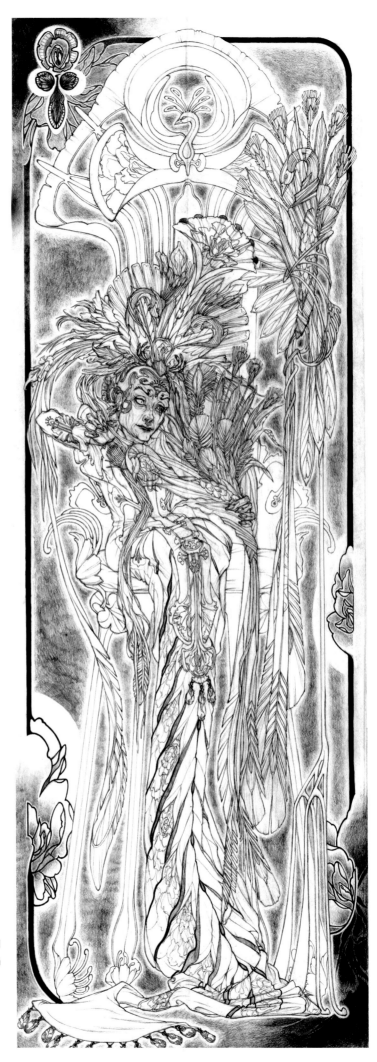

She is enjoying her floral arrangement, turning them into peacock bouquets.

royal deck: club | pavuquet

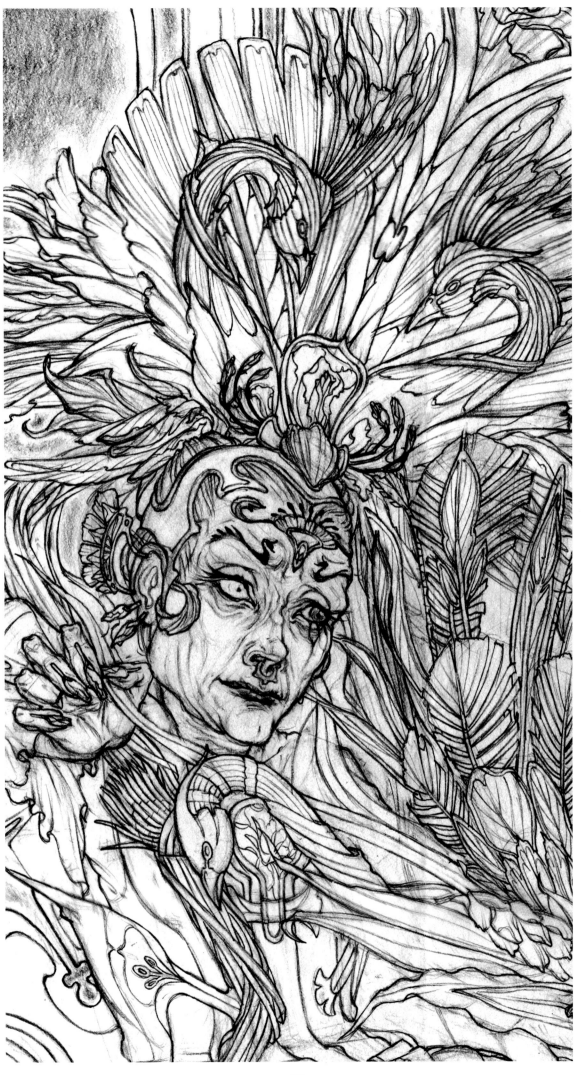

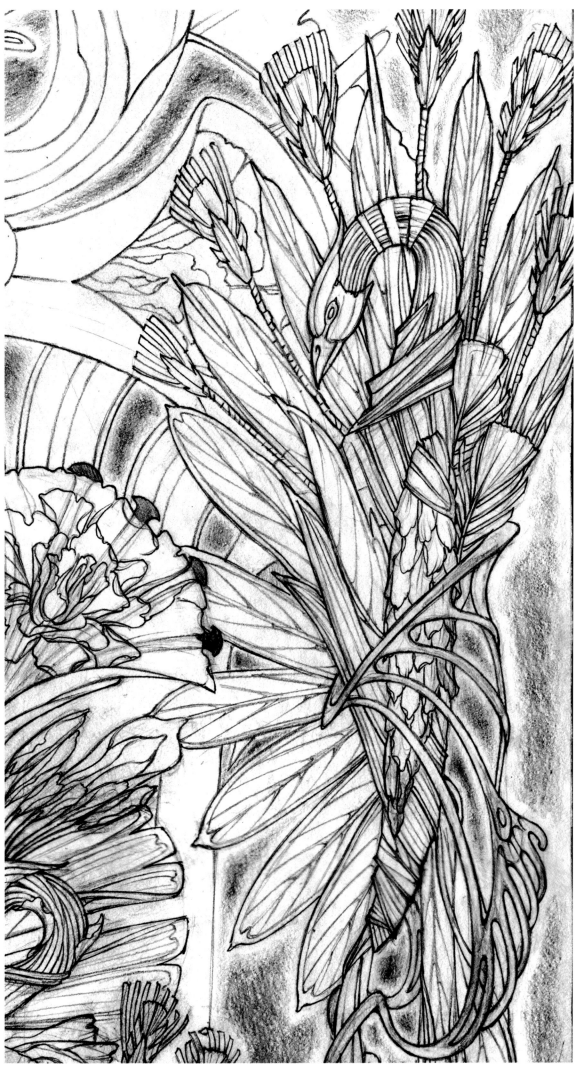

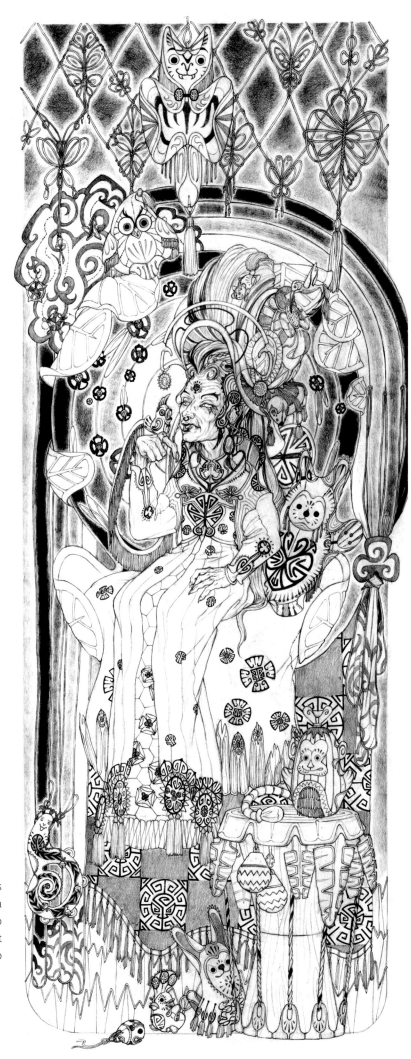

This lady whistles or sings into the bird, which has a microphone connected to speakers in the hat that transforms her notes into melodic forest music.

royal deck: club | hat of canarie

156

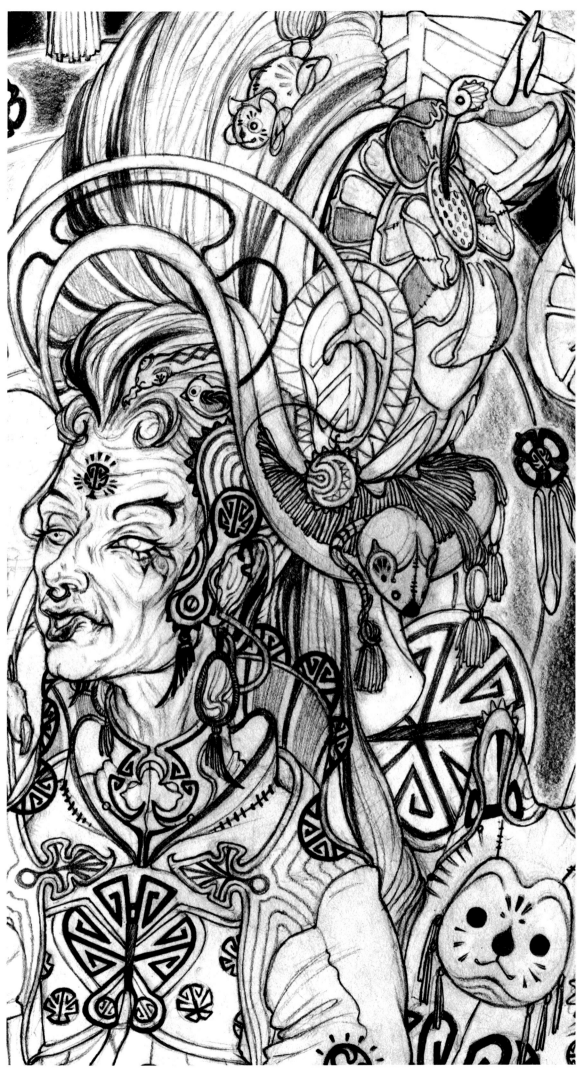

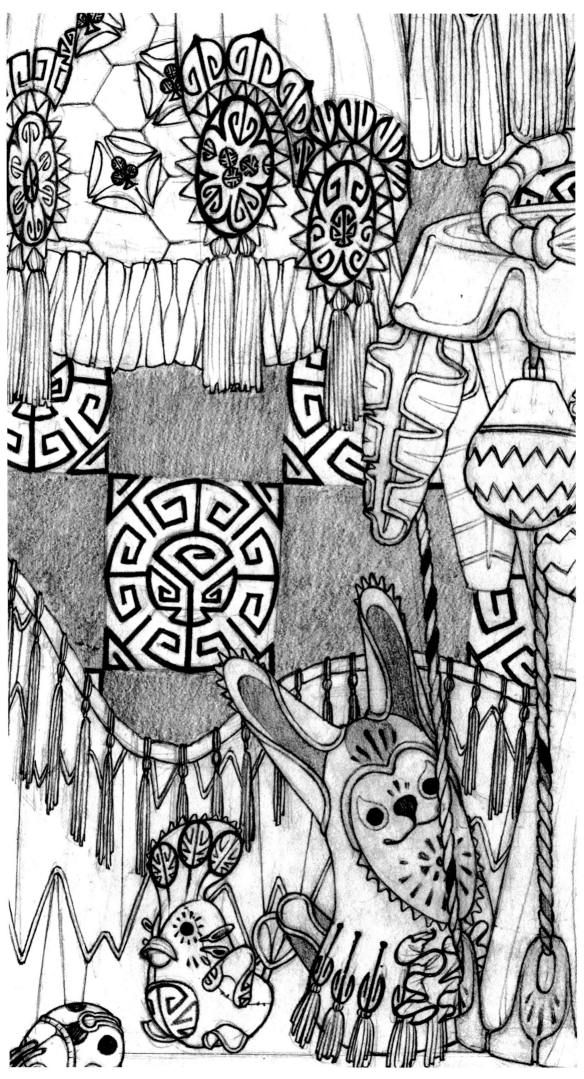